PORTLAND
FROM THE AIR

PORTLAND
FROM THE AIR

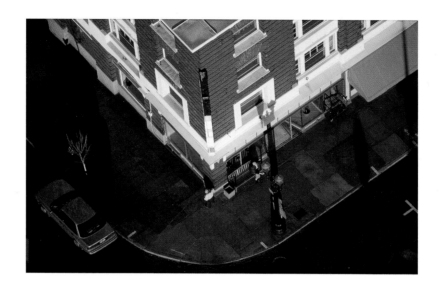

Aerial photography by

RUSS HEINL

Essay by

SALLIE TISDALE

Graphic Arts Center Publishing®

Text © MM by Sallie Tisdale

Book compilation © MM by Graphic Arts Center Publishing®

An imprint of Graphic Arts Center Publishing Company

P.O. Box 10306, Portland, Oregon 97296-0306, 503/226-2402

www.gacpc.com

Library of Congress Cataloging-in-Publication Data available upon request

Russ Heinl is represented by Image Network Inc.

16 East Third Ave, Vancouver, B.C., V5T 1C3

e-mail: info@imagenetworkinc.com

President: Charles M. Hopkins

Editorial Staff: Douglas A. Pfeiffer, Timothy W. Frew,
 Ellen Harkins Wheat, Tricia Brown, Jean Andrews,
 Alicia I. Paulson, Julia Warren

Production Staff: Richard L. Owsiany, Heather Doornink

Designer: Elizabeth Watson

Printed in Hong Kong

PHOTOS: *Page 3: Brick, cast iron, terra cotta, and wide sidewalks give downtown Portland a lived-in, European quality. The city is young but stately, an easy place to be.*

Page 5: One of the most beloved landmarks in Portland, the clock tower of Union Station marks a transcontinental railroad station within walking distance of downtown and the waterfront.

Pages 6-7: Portland is a city of bridges and rivers. More than a dozen cross the Willamette and Columbia Rivers, each with a different character. The Broadway Bridge is one of the city's busiest spans.

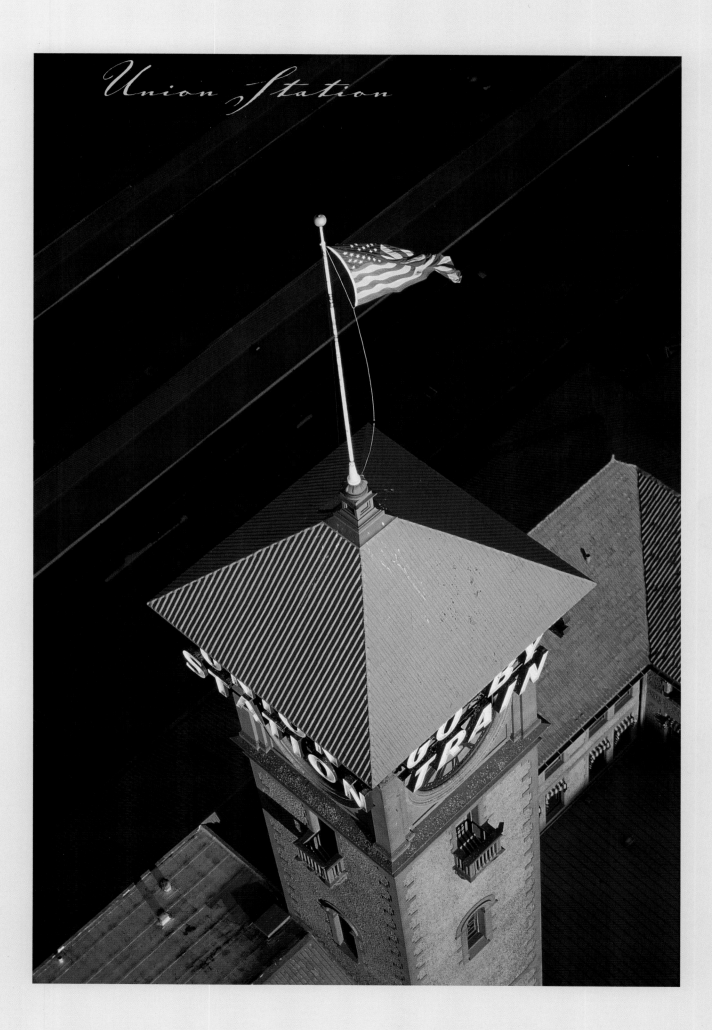

Union Station

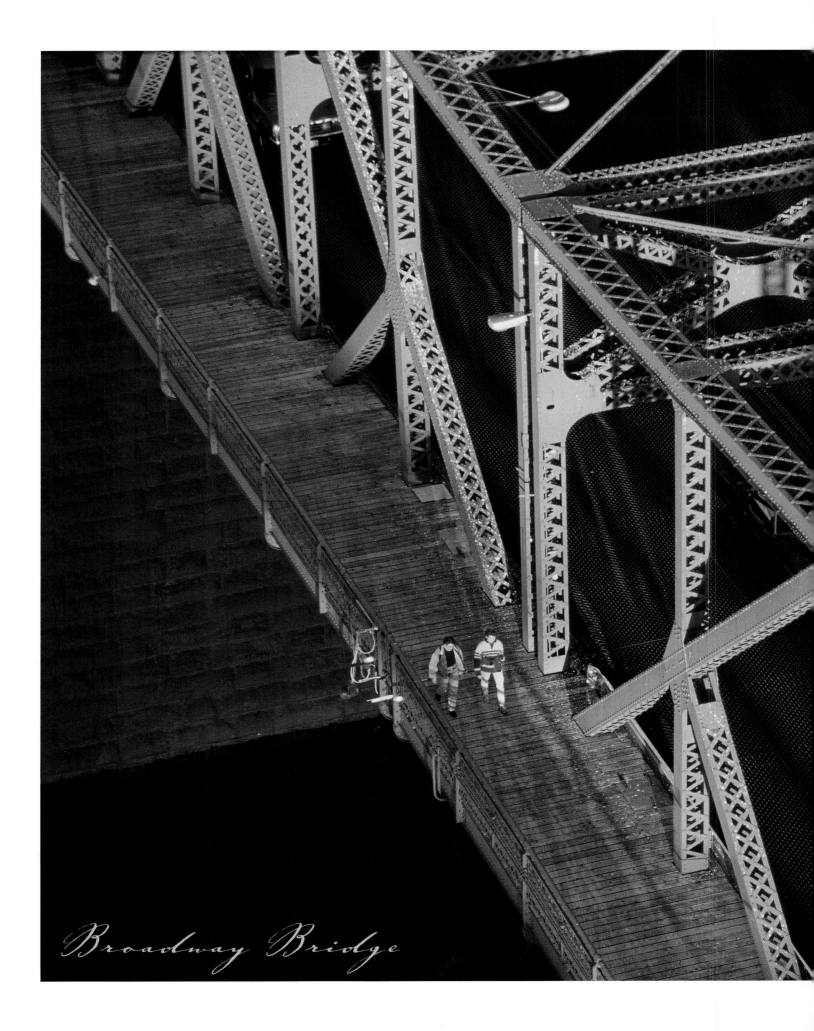

Broadway Bridge

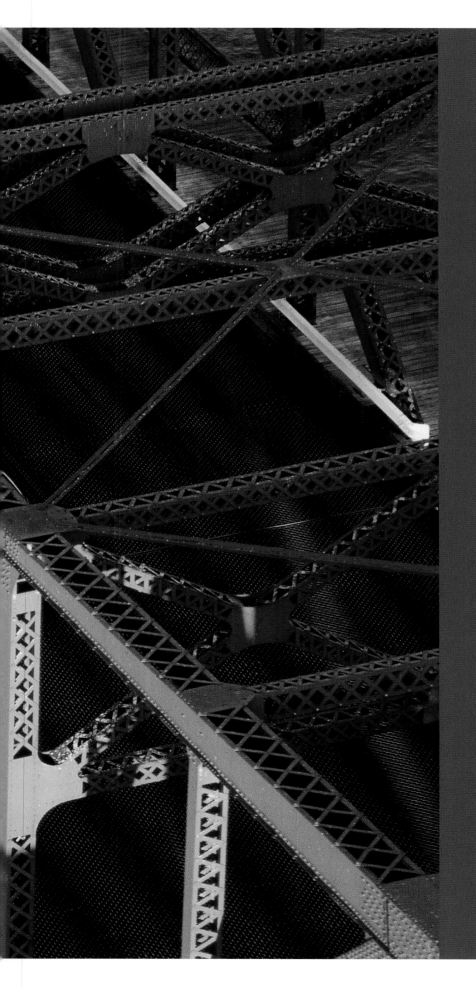

CONTENTS

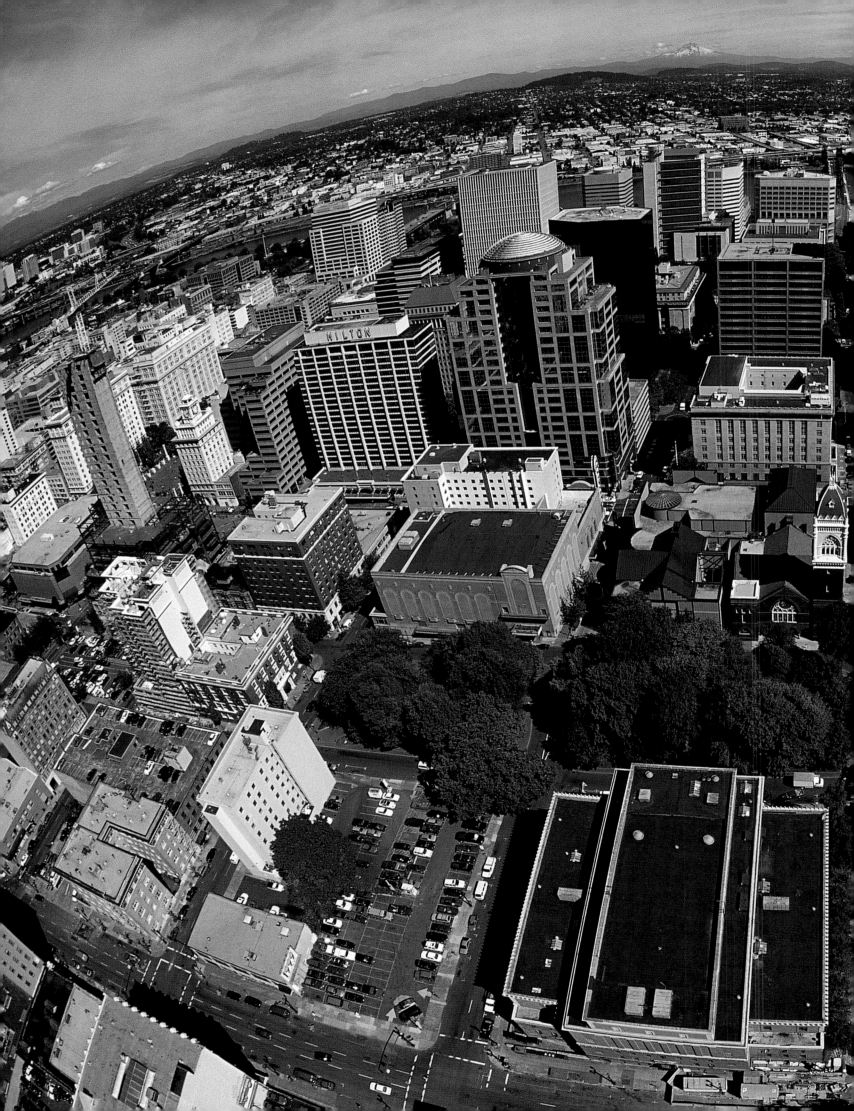

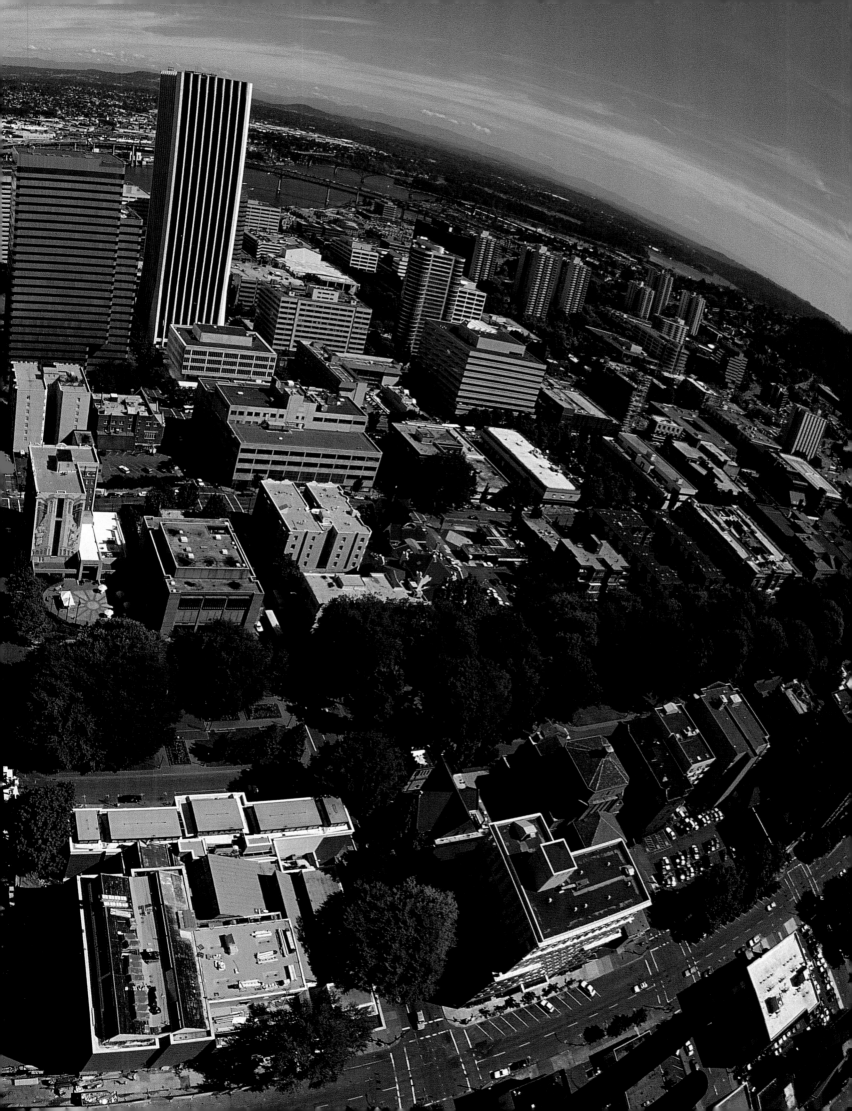

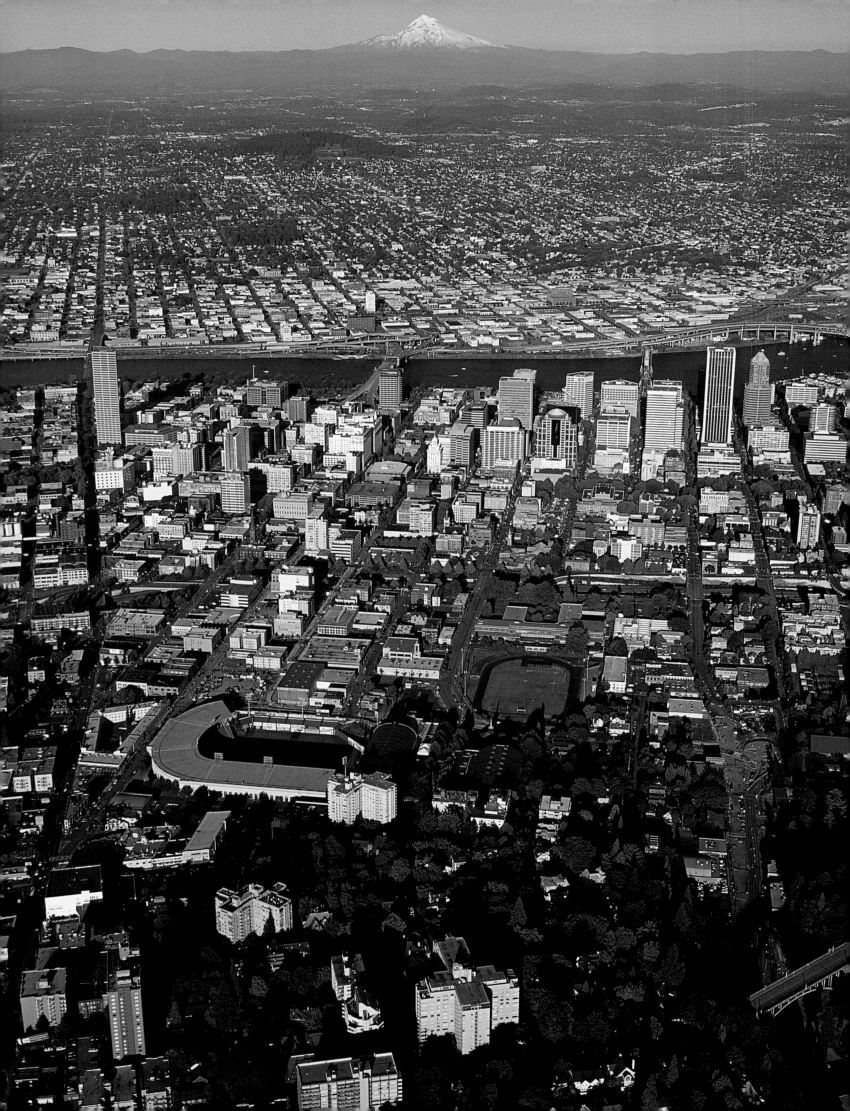

Home

Only from the air can we see how the world is made. Heights are privileged places, where long cycles are revealed—we see how the earth is broken down and put together again. The land is different then, not the land we had thought it to be. Steep mountains turn out to be mere foothills; a wide basin turns out to be the narrow valley between them. We see the serpentine pathways of rivers, sliding into one another like paint. In the midst of this rare canvas, we see home.

To return to Portland by air from the crowded east, the flat plains, the dry south, is to return to a world that seems newly born. A grassy expanse of fertile farms, a wall of white peaks—and a pale city, speckled with welcoming green and split by bright water.

This, the city below—that's the place to be. Home.

Portland is confluence—rivers and watersheds meet here, valley floors flow together. Their collisions are slow and quiet, but not entirely calm. Here is a durable beauty and abrupt change. Here is dissonance. Are we country or city, rural or urban? Are we conservative or liberal, casual or sophisticated? Are we all these things? The rivers run together in a deceptively silent pool, full of hidden tides and dark currents.

Almost two centuries ago, the naturally wealthy land and the ancient, prosperous Chinookan people ran headlong into the girdled restraint of white explorers. The Native people lived a rich and eventful life here, beside water

◄◄ The original dream of the city included an avenue of parks stretching from one end of the city to the other. The avenue is broken in places now, but the many shady blocks of grass, paths, playgrounds, basketball courts and benches speak to that first hope.

◄ The city stretches west into wooded foothills and east across a plain toward Mount Hood, the two banks sewn by the seam of the Willamette River. Water, trees, and the mountain frame the city from every view.

▲ Working farms surround the edge of the urban boundary.

so thick with fish it was said you could walk across on their backs. By 1835, just thirty years after Lewis and Clark had floated past their shores, the tribes were decimated by disease. Every year, more strangers came, trading, trapping, building—changing things fast. No one seems to have complained when someone cleared a small area on the west bank of the lower Willamette River. The thirty miles between the little settlement of Oregon City and Fort Vancouver across the Columbia River made for a long paddle, and the clearing was a resting place along the way. Portland was born a traveler's city—an "intermediary" place, in the words of historian William G. Robbins, "a point of exchange."

Exchange, but also refuge—the city began as a convenient picnic spot with a nice view of Mount Hood and remains one today. Portland is still a place for getting away from somewhere else, with a fair share of refugees and fugitives, people vaguely on the move. Itinerants pass through and never seem to leave; the town has gravity. All things run down to the rivers here—the rains and mud run down, the ships and the people, the wheat and timber and the gold, the money, the city's past and future.

The original claim was made by William Overton and Asa Lovejoy in 1843. They took that little clearing on the west bank and the 640 acres surrounding it. Overton and Lovejoy could have (and some say should have) claimed the east bank, which is much broader and just that much closer to the cities left behind. They chose instead the shady mud of the small clearing, a sheltered den between hills and water.

Overton sold his share to Francis Pettygrove and took off for parts unknown, another refugee. The core of the city was laid out in 1845, the same year that Pettygrove and Lovejoy tossed a coin over the name. Its original plat was touchingly small and human in scale: small blocks a mere two hundred feet square, each divided into eight 50-by-100-foot lots. The original city lined up with the river, not the compass. You can see that grid on every map, the center turned slightly away from latitude to face the river squarely. Of course—the river was why anything was there at all; the river was the only reason the clearing might become the center of anything.

The potholes in the narrow streets between those blocks were "deep enough to drown a good-sized child," wrote historian Malcolm Clark Jr. Early Portland was little more than clapboard, stumps, and mud. The few small

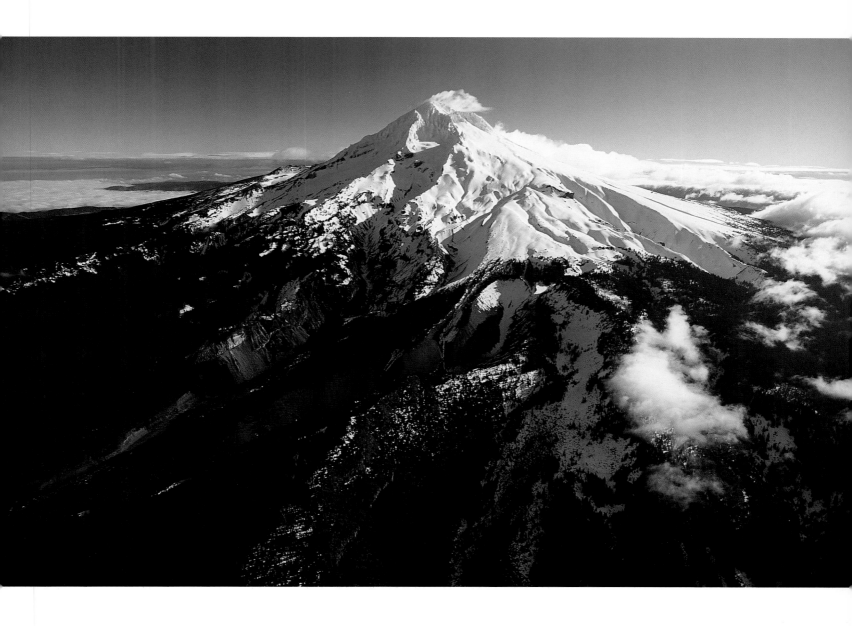

buildings were backed by a thick forest full of wildlife, a big potato field, a hopeful orchard, a pasture as muddy as all the rest. Most of the town was imaginary (including the row of blocks intended to be an avenue of parks stretching all the way through town). Imaginary, but big, thanks to several more 640-acre land claims in its first few years. Portland had fewer people in a larger area than most American cities by far, especially the big cities, the old, established cities of the kind that Portland has always longed to be and dreaded becoming at once.

Portland was born protected in that clearing between the Willamette and the hills, and it remains protected. This is not a tough city. We're safe from scouring midwestern winds and deep, frozen winters. We don't face ocean storms or huddle in prairie emptiness. More than anything, Portland's character is marked by this soft embrace of green hills, by the steady movement of the

▲ Mount Hood is a mountain for skiers, from beginners to professionals. The Palmer Glacier can be reached by a ski lift even in August. As soon as the snow melts, hikers appear on the many trails, which include a portion of the Pacific Crest and a loop encircling the entire mountain.

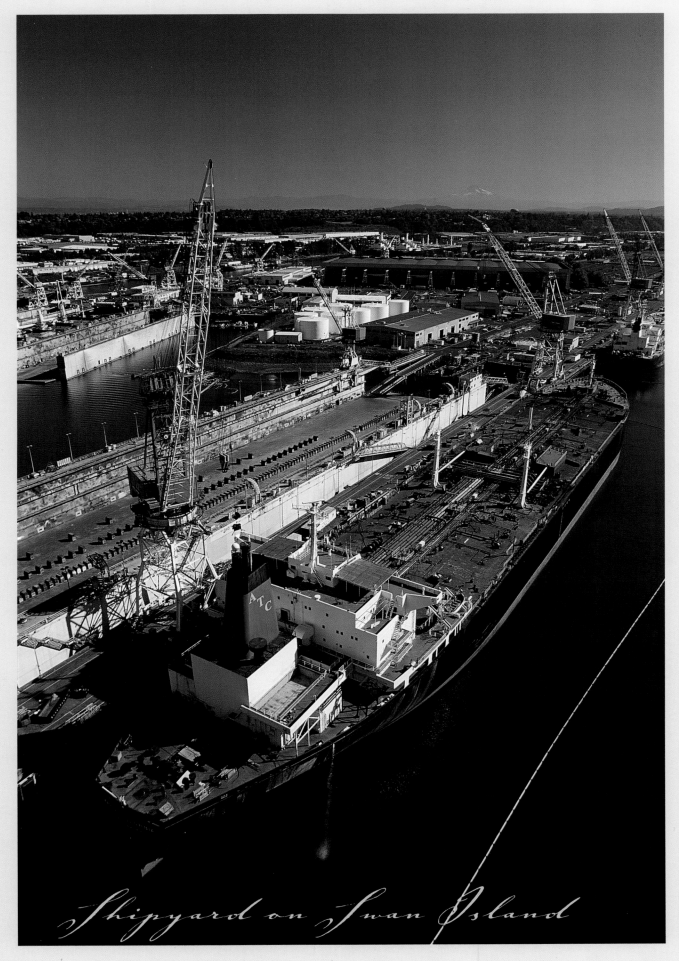

Shipyard on Swan Island

rivers, which run deep and strong. The shelter that Portlanders have always cherished has made the city what it is today—tender, a bit thin-skinned.

There is longing in Portland's heart, the dilemma of big-time dreams and small-town virtues, a twin yearning for bright city lights and dark country skies. This tension seems eternal. Civic leaders and supporters were never content with the natural gifts and great good luck of Portland's surroundings. They wanted respect, and notice—preferably from rollicking places like San Francisco and bustling, sophisticated cities like New York, places far away and as different from Portland as cities could be.

Local boosterism has always had a defensive character, though Portland had the "most skilled and persistent promoters" in the region, according to historian Carl Abbott. Portland's business leaders believed only one town could be the big town of the Northwest, and that one should be, of course, Portland—the leading city of "truly metropolitan importance," said one of the first clapboard merchants, his shoes still covered in mud. They feared every collection of huts around. The biggest rival was Oregon City, but the competition included (at least in some people's minds) St. Helens and Milwaukie, Linn City and Multnomah City, Milton and St. Johns.

Portland's hope of urban greatness was its river. Captain John Couch called Portland the "head of navigation" for the Columbia system.

Portland's hope of urban greatness was its river. Captain John Couch called Portland the "head of navigation" for the Columbia system—a long-unproved assertion spread as gospel by Portlanders and fiercely disputed by the civic leaders of every other town along either river. Still, it came true. Pettygrove built a wharf and a warehouse, and then other people built other wharves (double layers, one each for high and low tide) and other warehouses, and the ships came. The western valley wheat farms were so close, too—and so far, a dreadful twelve miles of steep mud cut up through what is now Washington Park and the pass where Barnes Road lies. A coalition launched the Great Plank Road (now Canyon Road) as yet another urban dream. They covered it in ceremony and fanfare and even a few planks, and wagon by wagon the wheat came down to the river. Gravity.

◄ The Willamette and Columbia Rivers combine in Portland to form a deep freshwater port, center for shipyard work and transport. Here, a ship docks at Swan Island, the industrial hub of river life.

By 1890, Portland had grown into a "snug and homelike" town, wrote Frances Fuller Victor. It seemed more stable than the exciting, fast-growing cities to the north and south and east—less blown by cosmopolitan winds, a little set in its ways. Portland grew deliberately, but also with a lot of

adolescent leaps and bounds, the population doubling and trebling every decade or so. The 100 people living here in 1847 became 2,874 people by 1861, making Portland three times larger than any other town in the region. In 1890, not forty years after incorporation, Portland's population was a whopping 46,385 covering both banks of the Willamette.

The city's first bridge was the Morrison, built in 1887. What a wonderful jumble of transport eventually crisscrossed Portland! Four transcontinental rail lines roared through. Local trains ran out to the valleys, up to St. Johns, to Vancouver and Oregon City and points beyond. Ferries crossed the Willamette; steamships ran up and down the rivers, as far as Eugene and Umatilla and the sea. Eventually there were 180 miles of streetcar and interurban train lines, a cable car climbing up the West Hills and at the top of Council Crest, a roller coaster.

By then, Portland's public character was firmly established, a character the city has struggled to shed and worn with pride in alternating moods ever since. Officially (that is, in the newspaper's cheerleading editorials and the public relations campaigns of various trade groups), it was a prim place of spacious homes on corner lots, sturdy businesses, a few stately public buildings. There were sixteen banks, nineteen newspapers and journals, two business colleges, two medical colleges, and sixty-three churches. Portland was a clubby town, with an upper class ever mindful of how long any given citizen had been in town—a class that kept its own social register and orbited around itself in restricted private societies, and, said Victor, the "usual number of secret orders."

▶ The First Congregational Church, built in 1851 in the city's year of incorporation, is one of many grand buildings in a city that built church after church—sixty-three of them in a few decades.

In its short, bright life, Portland has had many managers, many boosters, but few visionaries. (Those few haven't always made a difference. Early in this century, the architect Edward Bennett developed a plan for Portland based on a future population of two million people—a plan widely touted, officially accepted, and largely ignored.) For all the big plans, Portland was a little too prudent, a bit sober. Upstart Seattle began knocking the tops off its hills with giant sluices and washing the soil down for new land, while it raked in the Yukon gold and hustled industry like an eager party host calling strangers off the corner. Portland built small and elegant subdivisions, and a bridge. The bankers and businessmen who preferred a solid investment to risk were known as "mossbacks" to frustrated entrepreneurs and dreamers.

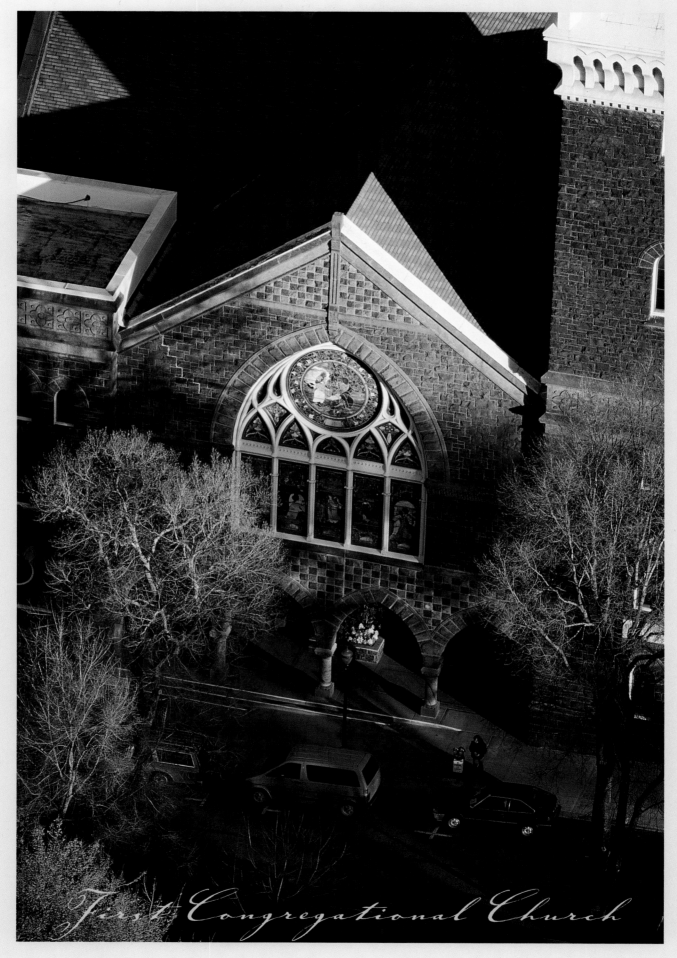

First Congregational Church

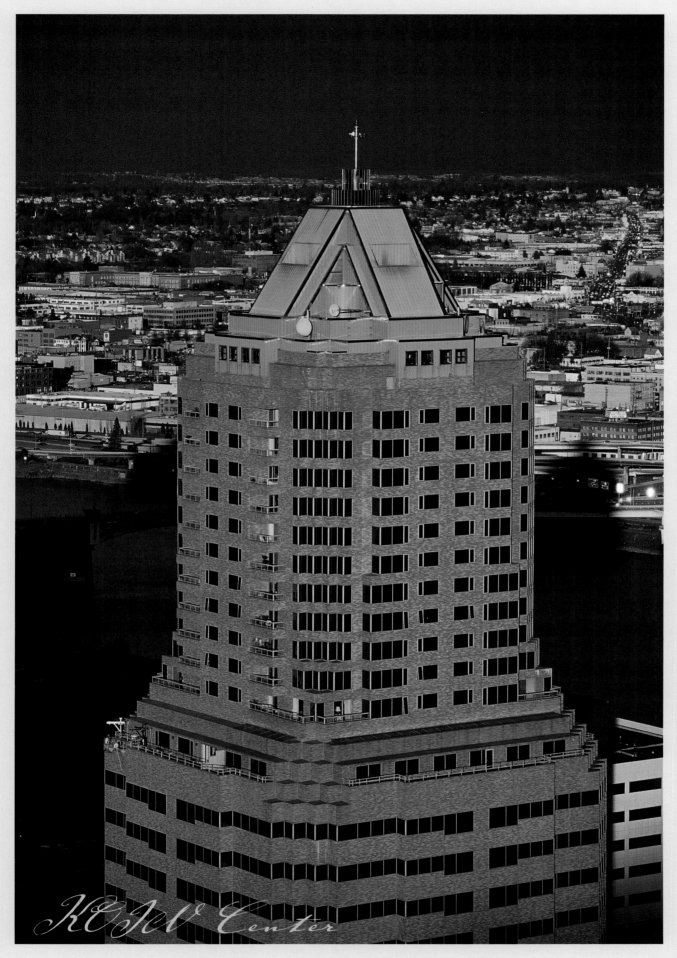

KOIN Center

Portland's leaders did want the city to be known for something—preferably something catchy and easy to promote. The word "metropolis" crops up a lot in old newspapers, along with various forms of "gateway to the Orient" and, according to a business paper, "the Oregon Emporium." Civic leaders were wont to make slightly moldy comparisons between Portland life and the society of San Francisco, the train yards of Chicago, the grand buildings of New York.

Portlanders were calling their town River City by the 1880s. By the turn of the century and a hundred thousand people, it was officially known as the Rose City. This was all part of a long, doomed campaign (with the grand Lewis and Clark Exposition at the center of it) to become a great city, the region's leader. And Portland did grow, in every way—but Seattle grew faster and bigger, San Francisco grew more cosmopolitan, Los Angeles more exciting.

Every city eventually becomes an organism, with a personality of its own.

Portland, even in its heady, late-twentieth-century expansion, still has the soul of a poor relation. It's a little shy, a little blustery, wont to talk too much at the party from trying so hard to fit in.

I've heard people describe Portland as "European" in character. At first, this seems an odd thing to say about a city so young and rough, a city that is still largely white and middle-class, but it has truth. Historians Terence O'Donnell and Thomas Vaughan pointed out that for a long time, Portland was "almost medieval in its plan—the city and then the fields." Its Old World qualities are especially evident downtown, in the short blocks and narrow streets, the small grassy squares, the brick and cast iron and terra-cotta facades of our old public buildings. In its latter days, as it was in its inception, Portland's downtown is people-sized, with a lived-in quality—a fine place, but not exactly a commonwealth. The streets are still a bit muddy.

Are we city or country—urban or rural? Perhaps we're just a bit medieval. You can keep chickens and ducks and beehives here. You can have a cow or horse if you have the room in your backyard. There are still pockets inside the city boundary that seem more family farm than town. These are shrunken pastures, to be sure, tiny orchards under siege, but the whole city blooms in every season. Christmas tree lots spring up overnight after the cornfield mazes and pumpkin patches disappear. Fruit stands appear on street corners and flower sellers at traffic lights and farmers' markets in bank parking lots, with

Its Old World qualities are especially evident downtown, in the short blocks and narrow streets, the small grassy squares, the brick and cast iron and terra-cotta facades of our old public buildings.

◄ The warm bricks of the KOIN Center house media offices, apartments, restaurants, and a popular movie theatre.

bluegrass music and the faint hollering of children, like the faint hollering of children at harvesttime anywhere.

At certain times, Portland has actually been European. Around the turn of the century, more than half of the residents were either foreign-born or the children of immigrants, and Chinatown here was second only to the great Chinatown of San Francisco. Francis Fuller Victor, like a lot of the city's staid establishment, resisted the implications. Portland, she wrote, was a "more American" city than places like San Francisco, and what she meant was that it was more white—a lot of the foreigners were Irish and Canadian and German, Slavic and Scandinavian.

Portland never had a great, wicked philanthropist, the kind who built the vast libraries, museums, and universities of the east.

In just such a way has Portland presented its confusion to the world. On the surface, the city was gentility itself—parades and picnics. Underneath, it was a cauldron of opportunism and vice. Private property ownership was a vague enough concept on a frontier dug out of stolen land—a vast region settled more by luck, theft, and murder than by noble notions of expansion. Portland's early leaders had, in the words of Malcolm Clark Jr., "overly flexible ethics" leading to all manner of scandal "sufficient to amuse the cynical." Various government scandals have come and gone ever since, mostly involving double-dealing, patronage, and fraud. A cabal of railroad and utility magnates helped develop the city without a whit of altruism. For all that, for all the shady developers, con men, and schemers in this town, even our vice wasn't really big-city style. Portland never had a great, wicked philanthropist, the kind who built the vast libraries, museums, and universities of the east.

▶ *The United States Customs House, with its Corinthian columns, sits at the northern end of the park blocks in one of the oldest neighborhoods in the city.*

Victorian Portland had parades and picnics; it also had at least two public (and a number of private) hangings at the first Multnomah County Court-house, built in 1864. Drunken men were routinely shanghaied for short-handed ships—delivering them was known as "crimping." Portland was a harbor town in all kinds of ways, full of drugs and gambling, with many of its leading families supported in part by an extensive and prosperous network of brothels—at least one floating. Segregation, redlining, and whole neighborhoods with deeds prohibiting "non-whites" are part of Portland's history, too. So is the Ku Klux Klan, which had a brief but public reign in local politics. So are the shantytowns and skid road, bleak housing projects, and cruel strikes. The ever-present struggle of the homeless and the working poor and the serious decline of the public school system—these are all Portland, too.

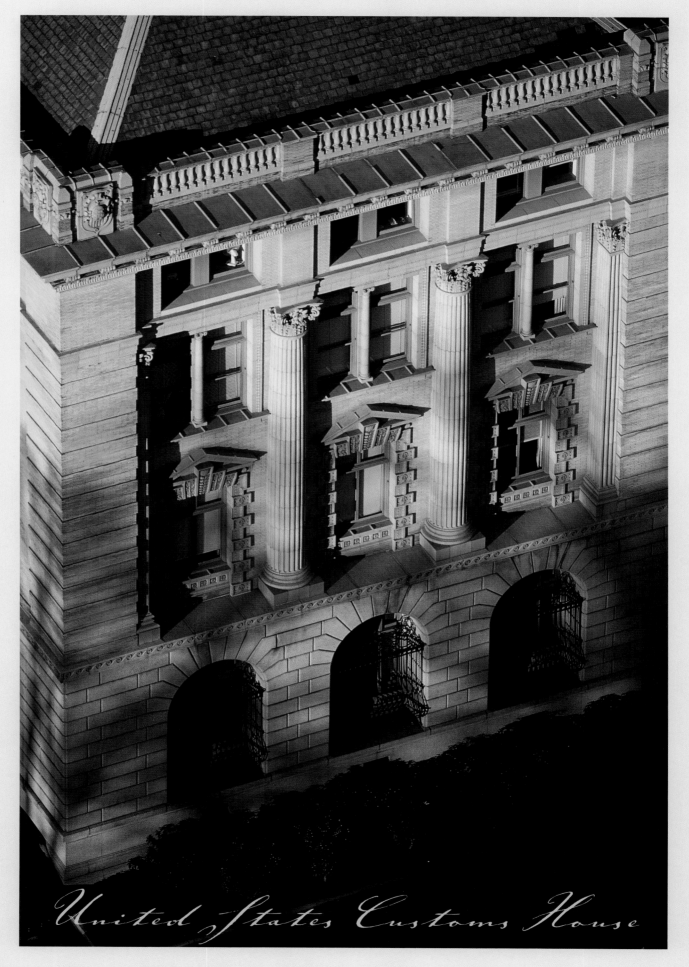

United States Customs House

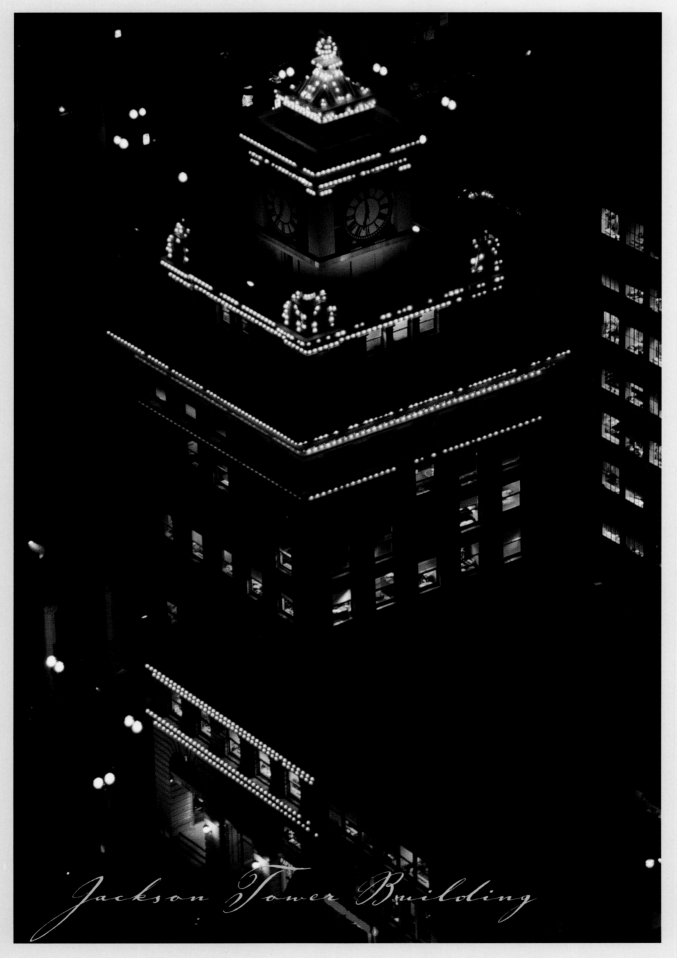

Jackson Tower Building

Oregon Territory was never in a hurry to be a state—statehood was a decided step down for such a free-wheeling kingdom, in many people's view. Even now, Oregon is outside the main currents. People are still moving here, from real cities like New York, Los Angeles, Chicago, and, yes, Seattle, because it is an easier place to be than those cities—a cleaner, more comfortable place, a seeming paradise to a lot of urbanites. But people move here knowing they are leaving the real city behind.

Portland is, for better or worse, for all its richer and poorer extremes, relentlessly middle-class. It is easily embarrassed, a little uncomfortable at the opera but not exactly a Mardi Gras kind of place. Middles always dream wistfully of ends, and Portland now and then dreams of being an opera kind of town. In our own particular middle, that desire and the fear of what it means merge like the rivers rolling together at the edge of town. Now that Portland looks more than ever like a real city, a destination, we are finding that living in a big city isn't exactly what we'd imagined.

New immigrants sometimes find it easier to enjoy Portland than old-timers do. Those of us who've lived here a long time are confused. (How long a person has to live here to be an old-timer is entirely dependent on how long the person judging it has lived here.) If a newcomer waxes enthusiastic about the place, they're likely to hear all about how much better things used to be. But newcomers are advised not to complain. We like our comfortable ways, the lack of formality and pretension. We want to be able to go to the opera if the spirit moves us, but we want to be able to wear jeans if we do. We like things the way they are and we wish they'd change. (A bit more night life, perhaps.) We say we're glad that we don't live in a *big* city, one of those other cities. But sometimes we secretly wish that we did.

The newly revised comprehensive plan for the city of Portland describes a city with an "intimate and human scale" close to unspoiled land. "Portland is more than a geographic area—it is a way of life," I read, and I know that any minute I'll find that word, the awful compliment that has haunted Portland for years. Sure enough: "Many characteristics combine to provide the unique livability of the city." It is our most dubious distinction, this "livability," an amorphous concoction of statistics dissecting the hopelessly complicated texture of this place. Portland ranks near or at the top of most such lists, and it

People are still moving here, from real cities like New York, Los Angeles, Chicago, and, yes, Seattle, because it is an easier place to be than those cities—but people move here knowing they are leaving the real city behind.

◄ *The Jackson Tower Building once housed the* Oregon Journal, *published by C.S. Jackson beginning in 1902.*

still somehow comes out in the middle. What a *nice* place, visitors say. When NBA star Scottie Pippen moved here in 1999 to play for the Trailblazers, he told a reporter, "It's a place where you kind of want to live."

How can you be a really big city when your own citizens compliment your "moderation"? That's not what one says of a place of "truly metropolitan importance," but a survey in the mid-1980s found it the most common word used: "moderate in size, climate, political activity, and in the pace of life."

Moderate—that's a lot like "nice." Even our weather is nicer than a lot of weather elsewhere. According to a climatic definition, we have only one month of winter a year: January, when the mean low temperature is below freezing. The sheltering hills mean mild days, though here "mild" translates to "pervasive." Instead of meteorological extremes, we have duration—dependability. The average rainfall is about thirty-eight inches, less than New York City or Houston, but it rains almost half the time. It rains hard and it rains soft, in drizzles and downpours, in mist and monsoon. Sometimes it rains out of a clear, blue sky. The rain is by far the most common complaint—but it's largely a moderate complaint.

Sometimes, too, the oaks and maples turn myriad shocking shades of orange and gold, sparkling among the dark pines and firs. The low, slow golden light of December breaks out of a splatter of cloud; a furry fog slides over the pond in the nearby park, over grass crunchy with frost. Torn thunderheads scud across a brilliant white moon, and the whole city wakes to the lethal tinkling of a silver thaw. One day each March explodes in warmth, and the stalks of spring bulbs shoot out of the earth. In the maternal heat of August when the tomatoes are stretching out of their skins and the birds stop singing to catch their breath, gravity takes over. To the river you go, running down.

Floating brothels and hangings aside, Portland's usually been thought a courteous town. Plain good manners? Or the serenity of lotus eaters? One can't always tell the difference. Either way, Portland's morality is more a matter of etiquette than sin. We're a fairly tolerant bunch, conservative and liberal and confused moderate in between. We're willing to live together—just not *too* close together. We pick up litter. Even in the cultural dishevelment of a new century, panhandlers are likely to say "please" and "thank you."

People talk to each other here. Portland's not much of a place for the kind of urban loner who likes skyscrapered canyons and a lonesome crowd. In

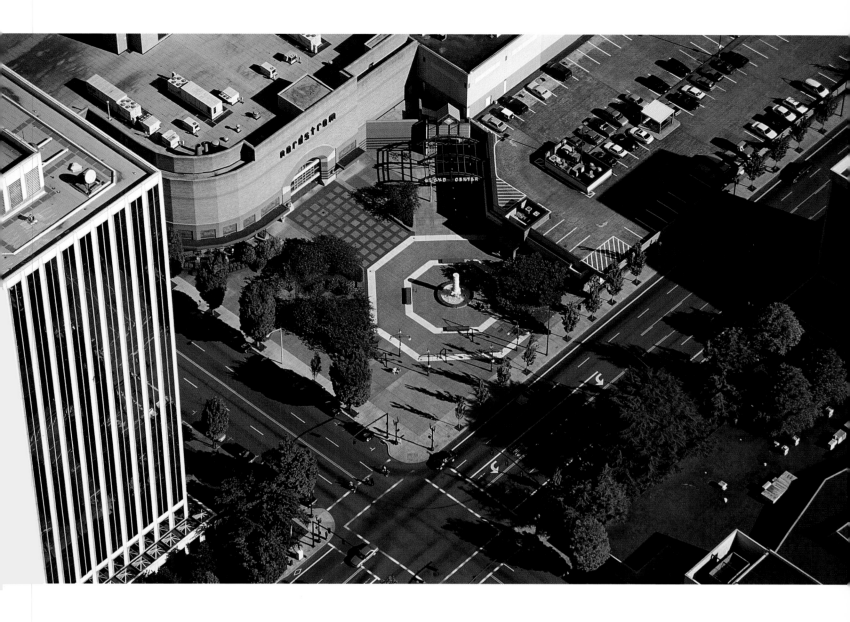

Portland, you are expected to converse—to give directions, tell the time, comment on the weather, and say "Happy New Year." On the MAX train, an East Indian visitor asks me where to get off for the zoo and the six other passengers in earshot all answer him at once and wish him a good time there. Beer is good—preferably local beer. Wine is good—definitely local wine. Coffee is essential; music is inevitable; books are unavoidable. You're expected to enjoy the local bounty like all good immigrants, whether it's strawberries in season or a cappuccino. We eat walking down the sidewalk, sitting on the curb, on the steps of Pioneer Square, riding bicycles.

The buses and trains are free downtown—that's nice. You can get a ticket for jaywalking. Guides in green jackets troll the streets, alarming visitors who don't know about these smiling people in uniforms. The guides steer the lost tourists who are staring at the handsome police officers on handsome horses

▲ *Department stores flank the Lloyd Center, one of the nation's first malls. The development was open to the air for many decades, offering shoppers of the rapidly growing Northeast neighborhoods a distinctive combination of street atmosphere and shelter.*

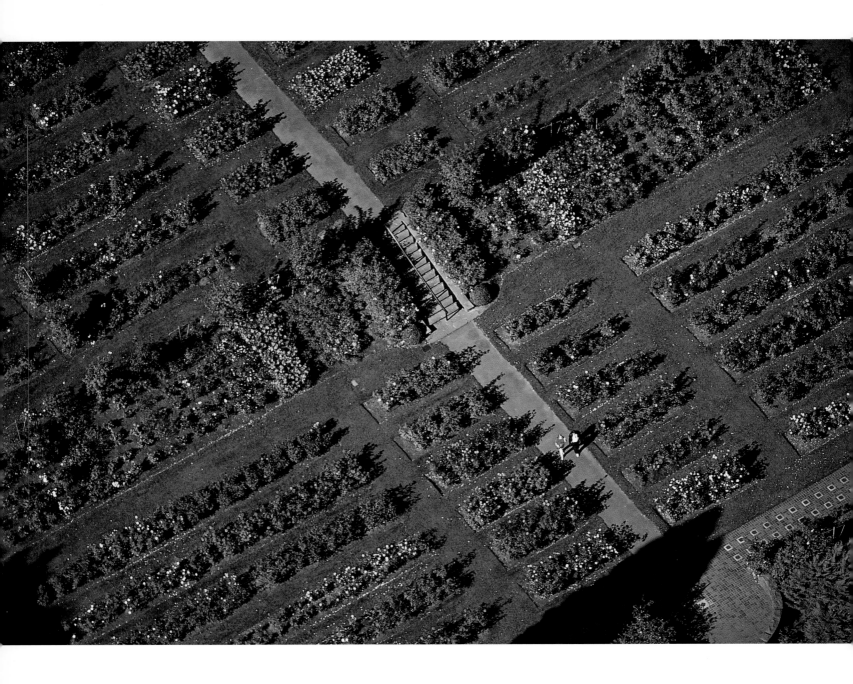

▲ The Rose Gardens host weddings, picnics, and concerts in a fragrant set of terraces above the city streets. The garden is in fact an international rose research center.

and shiny mountain bikes. We detour around the wet cement where the new wheelchair ramps have been built and ostentatiously hold up traffic for a squirrel. People take the time to make erudite analyses of bathroom graffiti. This is the kind of town where a gracefully aging drag queen commands as much respect as the mayor (and sometimes more, depending on the mayor).

Like a matron with a secret life, Portland has its peculiar immoderate appetites, too. We go for walks and comment on each other's gardens in a city with endless gardens: streetcurb gardens, backyard gardens, window gardens, container gardens, community gardens. Master gardeners on call, traffic jams at nurseries, brave young trees sticking up out of Volvo sunroofs. Portland has a new Chinese garden, a well-regarded Japanese garden, a capacious

rhododendron garden, a bishop's garden, a storybook garden, a koi garden, several estuaries and bird refuges.

Around 1901, the rose was chosen more or less at random to represent a city where an astonishing variety of flowers thrive. It quickly became, in Terence O'Donnell's words, "the object of a cult." Portland has one gigantic, famous, beautiful, public rose garden, and it has roses in nearly every yard, courtesy of a campaign by the women's Mystic Order of the Rose. Portland has a Rose Festival, a phantasm of rose royalty led by a Rose Queen—and in some years, all these roses bloom from April to November.

Today's city plan deems the rose an excellent symbol and suggests that people stick pictures of roses everywhere. "Portland design themes" (like roses and herons and raindrops and elks) are supposed to decorate our "street furniture" (lights, benches, manhole covers, bus shelters) and they do, most immoderately.

We like decoration. (Decoration is nice.) The city is dense with statuary: bears, beavers, elk, giant game boards, floating rocks, gentlemen with umbrellas, shiny and dull and bent and knotted sculptures. The giant auburn figure of Portlandia leans over from her perch on the Portland Building, reaching to the pedestrians and cars below. Joan of Arc wears a pumpkin on her head for Halloween and a Santa Claus hat in December. Murals, not all of them with roses, cover the city's walls. Water everywhere (all running down, down to the river in time): little four-bowl bronze fountains endlessly bubbling and house-sized block-wide fountains, for people to run in, slide down, hang over, and sit under. Big parks. Little parks. Parks with woods and forests, parks with islands, sand bars, and wetlands. Parks with a volcanic caldera or two. The biggest city park in the nation, an entire forest's worth of park.

We are most immoderate with our trees. In a city built over clear-cuts, a city made out of timber, a city once called Stumptown, we have trees. So many trees—the dark-treed hills rise above the pale sea of houses from every view. Trees on every curb. From above, where the Vaux's swifts dart and a pair of peregrine falcons soar, there are so many in trees that almost half the city is under the trees' canopy. The few treeless avenues stand out. So many trees, and the cutting of a single one provokes heated argument. In the spring the trees drip with faint green, limp and delicate. In the summer, they tower in full strength. In the fall, they are overnight washes of red and flood the streets

Portland has one gigantic, famous, beautiful, public rose garden, and it has roses in nearly every yard—and in some years, all these roses bloom from April to November.

with yellow. In the winter the bare bones whip in the wind, rattle with ice, crash into our cars, our living rooms, our roses.

I wanted nothing more than to live in that most charmed of places, that Paradise, Buonaventura, that Great River, that Oregon." So I wrote in 1991: I was remembering how it felt to fly into Portland, to come out of the browns and grays of Los Angeles and gaze down into the valleys of home. "Watching it, I was afraid I would wake from this good dream, this best dream of all, with a shiver of grief at its passing." I still feel this shiver, coming home. I am afraid because so much has been lost, because there is still so much to lose.

I know from time spent in other cities, bigger and older cities, that Portland has been lucky—even wise at times. That doesn't mean we're going to be lucky or wise again; this is a young place, still immature, still uncertain. The bright, wide valley of our rivers has drawn its immigrants here because it is a place of tremendous gifts. We who live here are marked by these gifts and by the endless urge to tinker with them. We will improve our Eden. Even the two divinely useful rivers needed fixing: the waterfalls had to be fixed with locks; the channels, dredged; the rapids, flooded; the banks, walled and wharved.

Lovejoy and Pettygrove's original plat was a good one, but everyone seems to have forgotten about the waterfront. For decades it was unclear whether the city's central raison d'être was public or private land. The riverbank filled with warehouses and wharves, but the ownership of the bank itself was a matter of long dispute. Portland's first appearance in the United States Supreme Court was an appeal from a private citizen who wanted that bank. The Supreme Court refused to overturn the territorial court's 1853 ruling in favor of public access, but a similar federal court suit a few years later found against the city. For the next fifty years, the waterfront had no public docks.

The rivers are still central, still rising and falling with the tides of an ocean more than a hundred miles away. They will always be central; every day we see, hear, smell, and cross the rivers. Business never stops: giant grain ships rock gently next to huge, smooth silos like outlandish kids' toys looming over the bridges. The wheat, timber, and corn still come down; cars, steel, and oil still come up in massive container ships. All day the ships chug slowly into the city past industrial complexes, giant tanks and storage sheds, huge parking lots and small manufacturing plants, mountains of glass ready for recycling and

The rivers are still central, still rising and falling with the tides of an ocean more than a hundred miles away. They will always be central; every day we see, hear, smell, and cross the rivers.

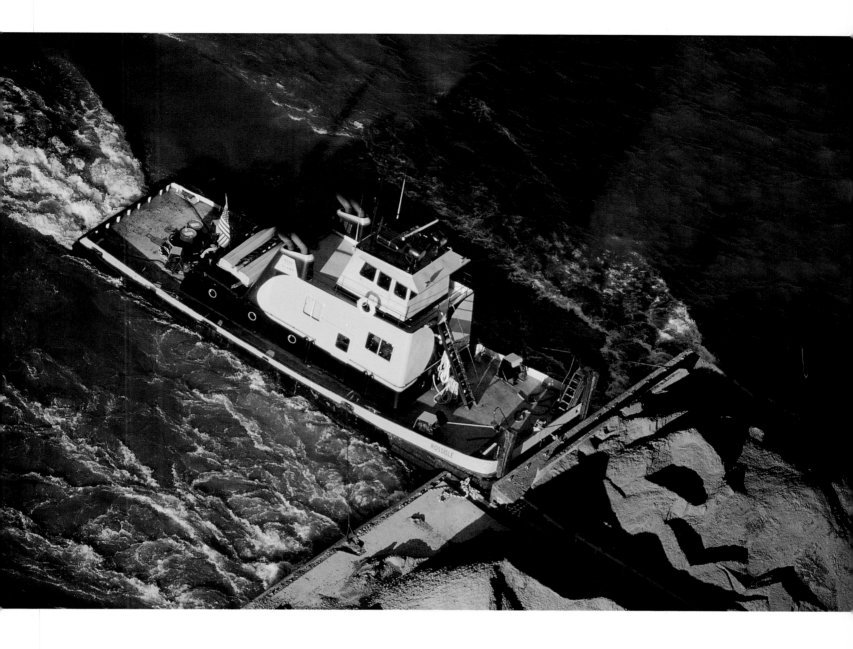

big trucking warehouses. Updated sternwheelers and party ships share the lanes with speedboats, water-skiers, jetskiers, houseboats, canoes, dragon boats, sculls, catamarans, yachts, and tugboats in a constant jostle of private enterprise and play.

I try to imagine the old waterfront. I try to imagine no public docks. No eastside view of the downtown streets. No grass. No flocks of sailboats. I try to imagine the crowded, rickety double wharves hidden behind masted ships. I think of the long, empty seawall and office buildings that followed the wharves. I think of the six-lane Harbor Drive highway, too dangerous to cross. I try to remember—I think we all should remember—that River City didn't truly claim its river for more than 125 years.

I follow a street I haven't driven for a few months and the stores are

▲ Tugboats are a common sight on the rivers. Barges filled with grain, logs, sand, and gravel slowly plow the waters under tug power.

up-ended, new. I windowshop as though in a foreign city—full of surprises. Houses appear and disappear; buildings vanish and arise seemingly overnight.

In 1938, Lewis Mumford asked the City Club, "Are you good enough to have this country in your possession?" It was an appropriate question to ask of a city of declining neighborhoods and growing sprawl. For a major part of this century, the answer has seemed to be, "No."

By 1930, Portland had grown to 301,000 people, and was clearly destined to be part of a "metropolitan area"—not exactly a metropolis, but a rapidly changing and surprisingly big place demanding plans—plans that didn't come. Instead, the streetcar lines were torn up and the ferries put to rest. The cable car came down and so did the roller coaster. Portland's urban landscape suffered a Depression, a wartime industrial boom, and a reactionary postwar withdrawal. The river became a sewer, a seawall, a highway flanked by parking lots. The invitingly small blocks and narrow streets designed for walkers and horse-drawn carts were turned into one-way alleys filled with cars. Fine brick buildings were torn down for more parking lots, for more cars. The urban neighborhoods where people had lived and worked—the kind of urban neighborhoods that real cities have—were torn down to make symbols of cities, sports stadiums and freeway exits.

Throughout the postwar years, Portland grew, steadily approaching the half-million mark. It had long ceased to make sense to count just the population within the city limits proper. We suffer from a misperception; surveys show people still think of Portland as having about 400,000 people. But Portland is one with its neighbors, in a metropolitan region covering more than 460 square miles in three counties and holding more than 1.2 million people. In the last fifteen years, our population has grown at twice the rate of the United States as a whole.

Throughout the city are small spheres, once separate, with houses, stores, and trees of a certain style and age. Portland proper has grown largely by annexation—Albina, East Portland, Sellwood, and various early subdivisions all taken in. St. Johns is annexed. Linn City and Multnomah City are part of West Linn now. Milwaukie, Oregon City, and St. Helens are suburbs now. Milton is flooded and gone. The outlying villages have been absorbed, soaked up—small local flavors intersecting each other inside the consecutive rings of urban growth.

► Housing developments have grown up rapidly around the east-west light-rail line, seen here disappearing into a tunnel. The southern edge of Washington Park, a complex mix of wild and tame land, is visible in the background.

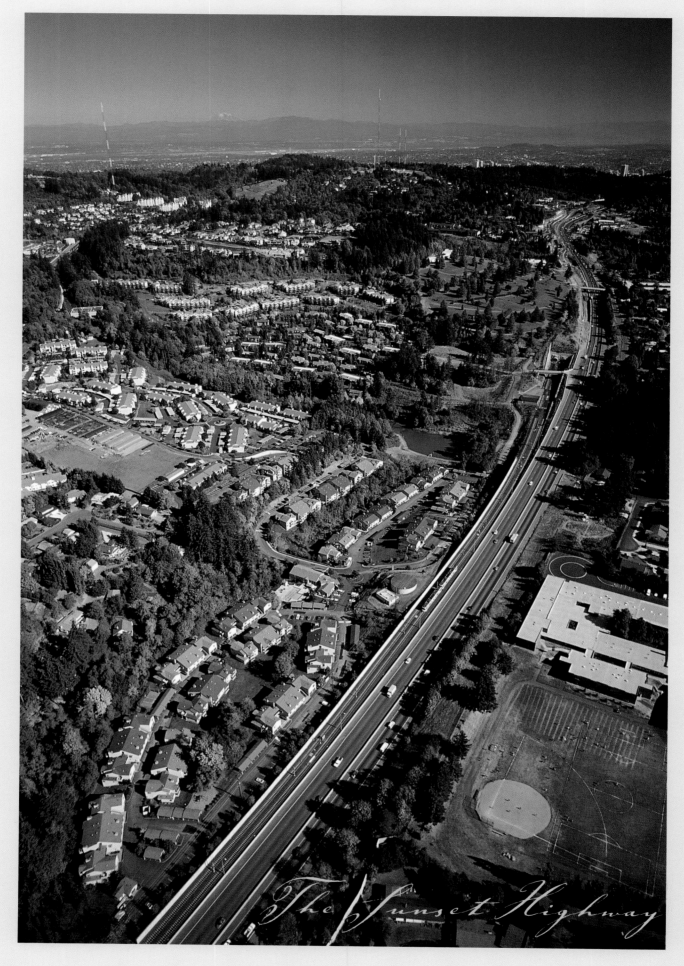

The Sunset Highway

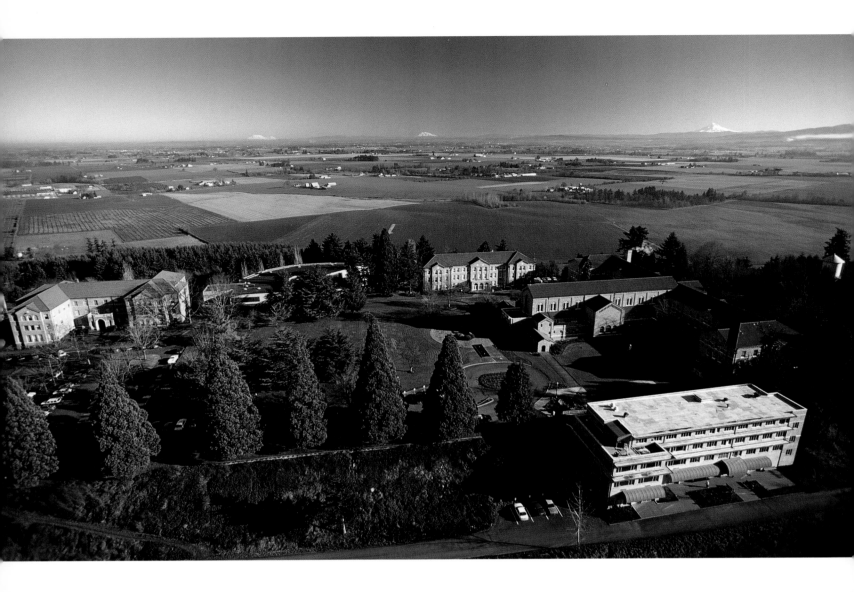

▲ The Mount Angel Abbey is a quiet campus in the farming community of Mt. Angel, south of Portland. The valley is filled with nursery stock and vast fields of flowers.

Local maps are threaded with complicated regional splits, a seemingly illogical twisting and turning. These are invisible borders: cross the street and you cross towns. Portland's city boundary wanders, turning at right angles and snaking in curves, cutting out jigsaw pieces here and there. It follows the river, the freeway, the line of a natural canyon for a while and then suddenly deviates, leaving odd peninsulas and archipelagos. Here and there one finds a sign—"Leaving Portland" or "City Limits"—with no apparent change in one's surroundings. And now and then I look up to find a sign informing me that it is just so many miles to Portland, and I hadn't even known that I'd left.

Portlanders point to the fact that the city is inside the nation's first Urban Growth Boundary. The UGB is a zigzag line cutting across counties and around towns and suburbs, sharply dividing urban density and congestion from farmland and forest. The UGB is supposed to control suburban sprawl, that endless spread of strip malls and bad housing developments eating up

rural land from which other cities—big cities—suffer. The reality of how it works is something else again, because a city needs more than a wall to grow well. Outside the boundary, much has been protected—the bountiful Oregon soil still falls away from the city noise into meadows, woods, and streams. Here and there, the traveler finds strange exceptions to the rule: Wal-marts, factory outlet malls, enormous industrial complexes surrounded by pasture and field. But for the most part, the country outside remains country; it is the real and psychic context for the life lived within. But that life is increasingly one of bad growth; inside the boundary, almost anything goes.

In the growth of the last few decades, hills, meadows, and commanding vistas have been swallowed by developments and office buildings. Spacious grasslands are now covered in houses. A giant's bouquet of fir and hemlock has been cut down. Sometimes I drive through streets of bad dreams, scattered all along the city's edges. I follow narrow, winding roads designed long ago for sparse rural traffic, and I pass through unending urban congestion, along narrow sidewalks pressed between townhouses and sprawling apartment complexes. I wander oddly graded new streets dug out of the slopes of eroding hills, between inflated mini-mansions separated by wide, empty lawns. I drive—because there is no choice—from one silent group of houses to the next, trying to find a grocery store, a bank, anything to make this more than sprawl—to make it that magic ingredient of cities, a neighborhood.

By the mid-1970s—a generation ago—one could look at Portland and see terrible losses. One could also see magnificent plans. The city was blossoming with new urban passions, with the angry love of people who refused to let the losses be. Led by Neil Goldschmidt—a leader the likes of which the city has not seen since—a grand renewal of the city center took place within a few thrilling years. A grassroots campaign to stop another crosstown freeway actually succeeded, and the money saved helped to build a crosstown commuter train line. "Metro" was born, the nation's first elected regional government commanding a significant part of Portland's future along with that of three counties and twenty-three other cities. (Metro gave birth to the Urban Growth Boundary.) The Harbor Drive highway was paved over in a new way, with grass, and became a waterfront park. The parking lot in the center of downtown became a town square. Some of the one-way streets became a mass-transit

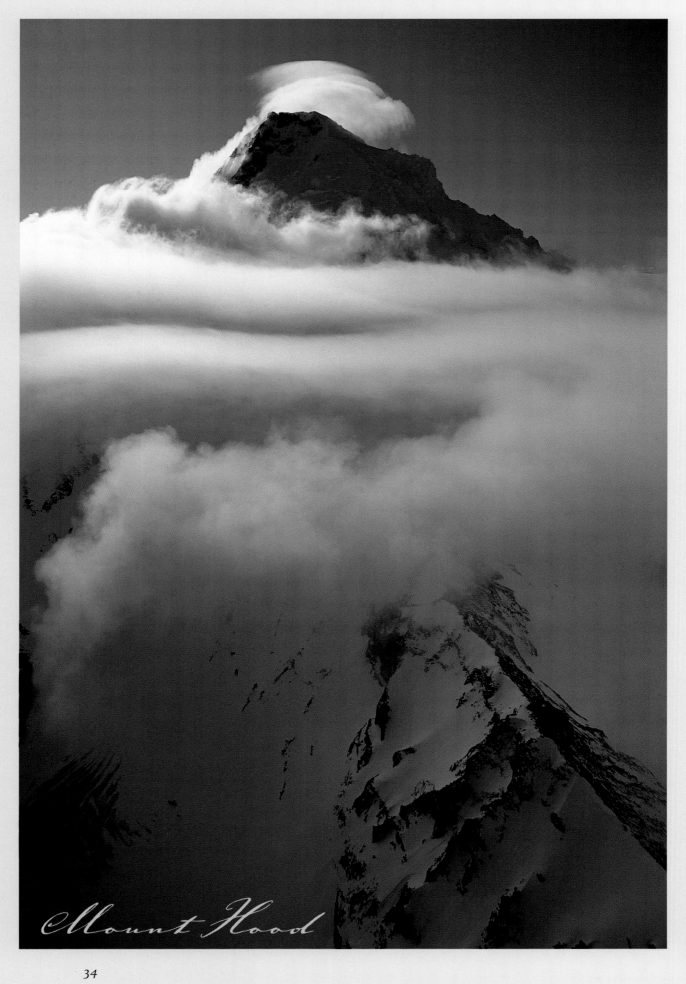

Mount Hood

mall, feeding new urban housing living in the midst of a century of truly beautiful architecture. Today, even the streetcar is returning. Portland could still be a city, a real city—not a big urban center, not an industrial leader or densely packed metropolis, but something else. Something unduplicated.

I stand on the bluff fortuitously named Overlook and trace the impenetrable, dark reach of Forest Park. I count the thick-trunked conifers that still shadow the precarious manses of the West Hills. I gaze down on the ships below, so comfortable in their wide, wet berths. I look up the river and see the sandy reaches, the wetlands and islands, the flocks of migratory birds. I can hardly imagine the sweep of those original 640-acre claims, what wealth they contained, what glorious luck they held. Stumptown, a muddy, mean town smelling of the tannery and horse manure, its sticky streets a hazardous maze, slowly picked its way up and out and spread into the hills and along the flooding banks. But the slow sprawl left oases—deliberate and accidental—scattered about. We still have breathing room between the towers.

From the air, the snowy expanse of sunlit morning clouds ends abruptly, and there is only blue water below and the unmistakable outline of Puget Sound. The plane turns south past the snow-sprinkled Olympics, over land seen through broken heaps of clouds. Stretches of autumnal hills that rise to big peaks. There, the blunt masses of Rainier and Adams—there, the lopped top of St. Helens. Under a great sun filling the sky with wide, free light, the land looks endless and empty. The plane drops and follows the long Columbia, a seam between lives. Details appear—fields and clearcuts, the grids of small towns, thin roads. This distance, this particular vantage, contains the past and all possible futures. Down below is where the fish once swarmed so thick you could walk on their backs. There is where the first traders came to land. There is a clearing for a midday rest, with a view of the water and a beautiful white peak.

From this height, today, I see bounty, the land stretching out like a yawning cat, unconcerned. Two fine, wide rivers meet here like no other rivers in the world, meet and merge and define this place—a city of confluence in a low, guarded clearing. I see the luminous glow of morning on the silent mountain, and I think it is so close that I could reach out, right now, and be there.

I see the luminous glow of morning on the silent mountain, and I think it is so close that I could reach out, right now, and be there.

◄ *In a certain light, Mount Hood appears to be only a few miles from the center of the city. Portlanders gauge weather and season against the mountain's clarity and color.*

► *Just after sunset, the hills of the Willamette Valley south of the city still glow with fading light. The Fremont Bridge forms a sweeping arch over the industrial banks.*

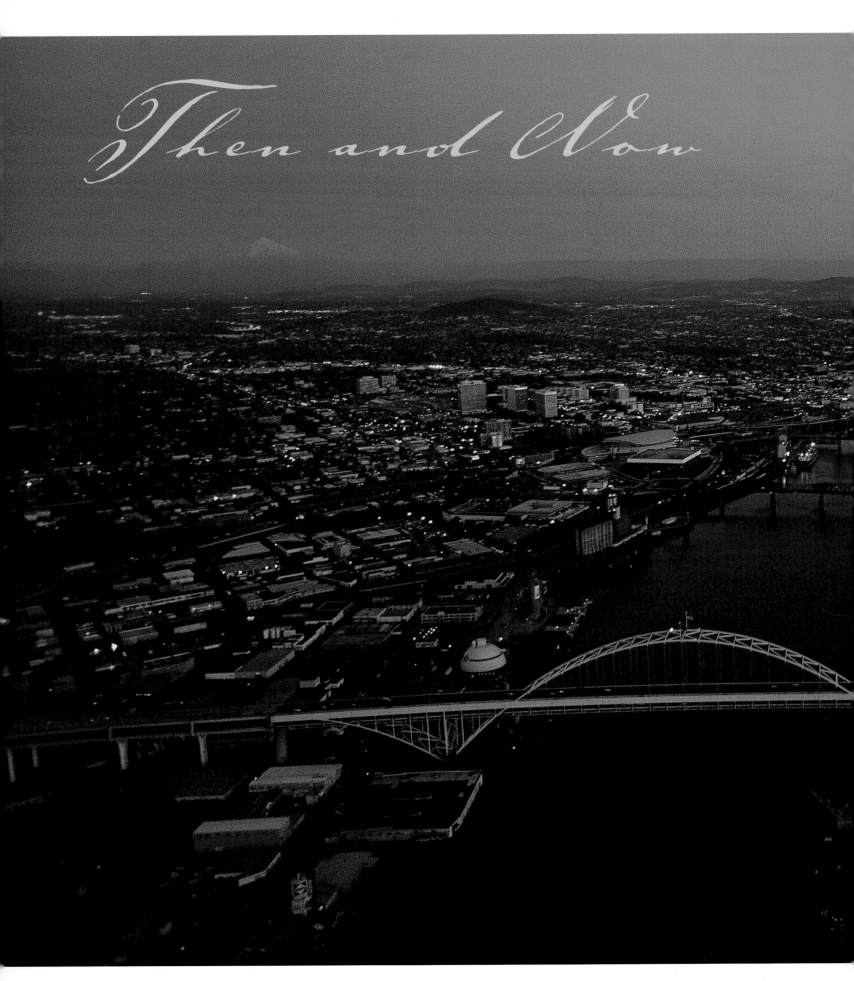

Then and Now

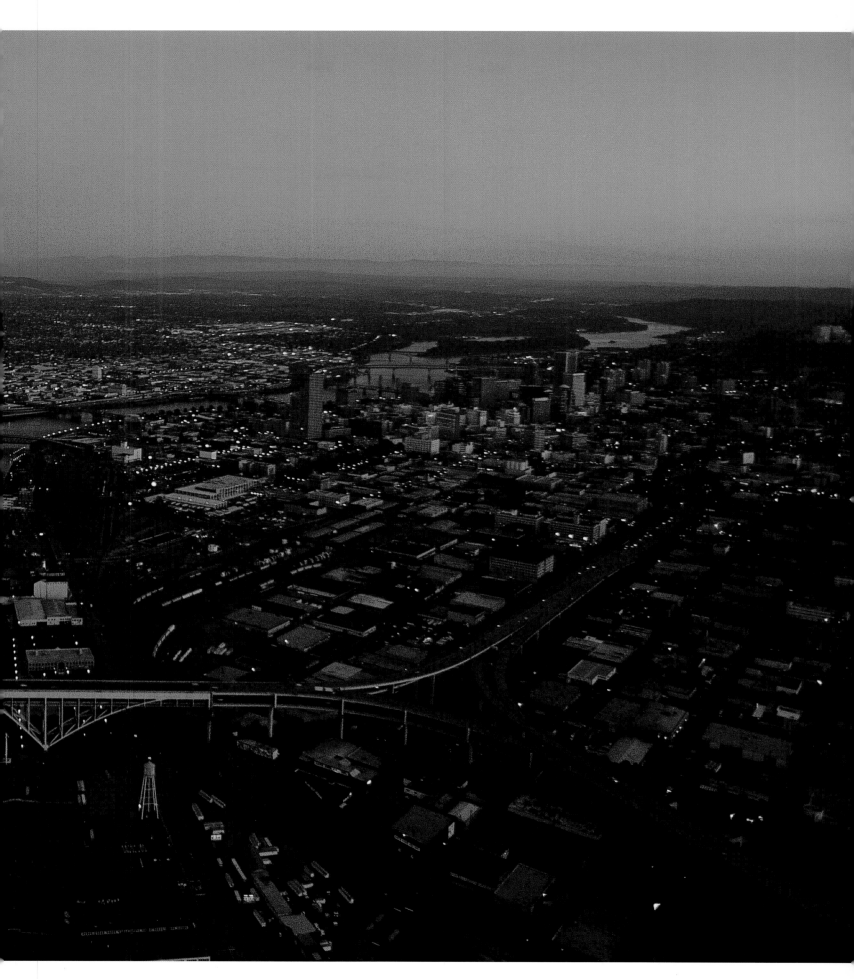

Several of Portland's bridges were built by private enterprise and then sold to the city by developers hoping to open the east side for housing. The Broadway Bridge at the bottom of this view is one of several working drawbridges across the river.

1929

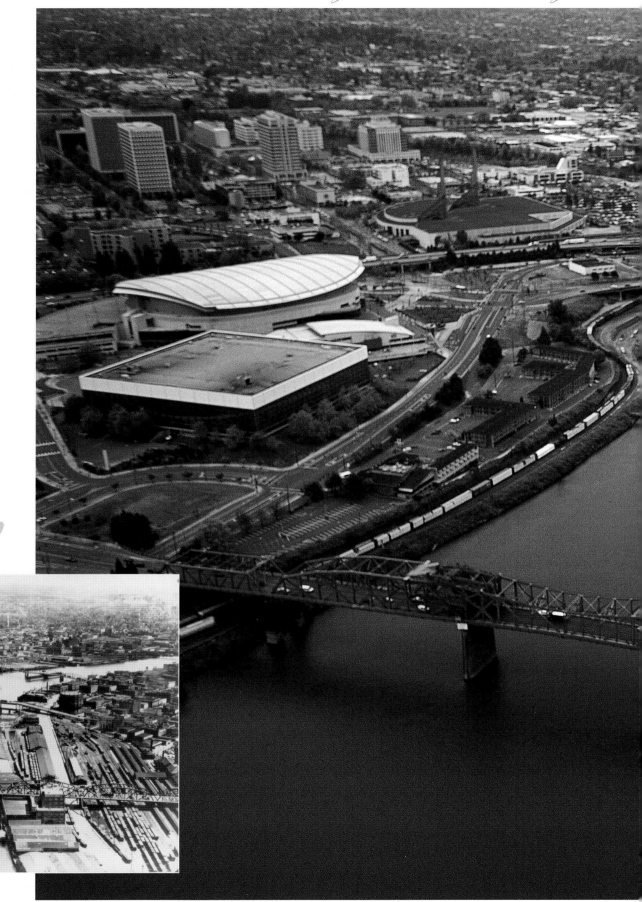

PORTLAND ORE.
©PRENTISS.

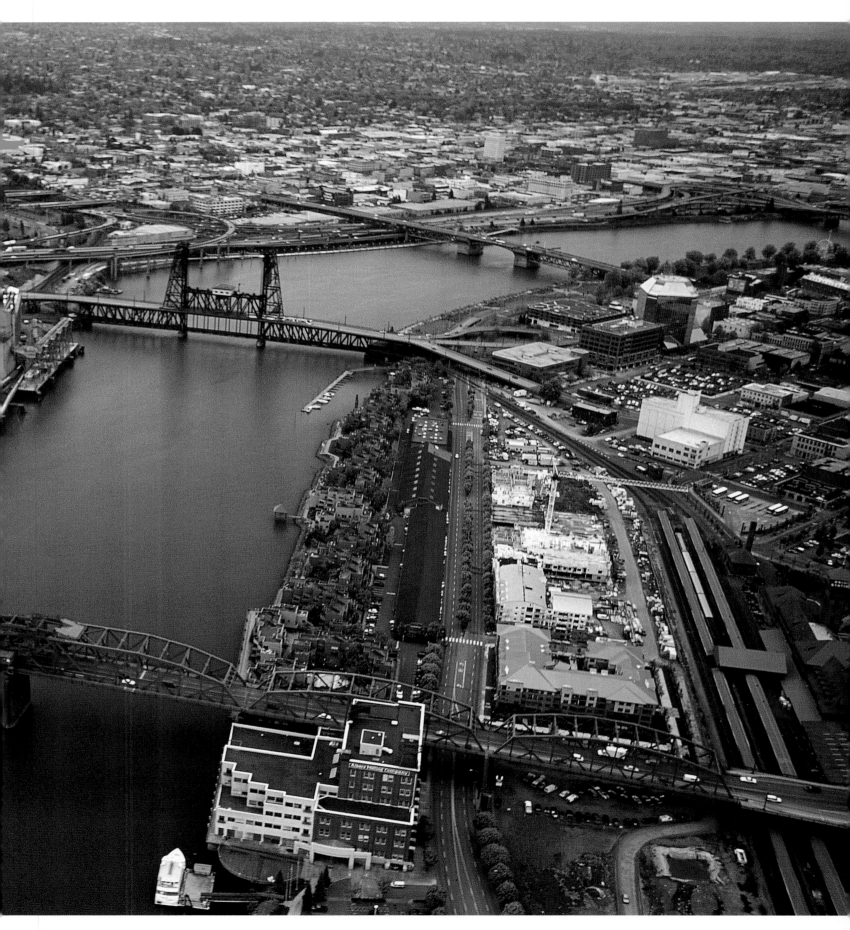

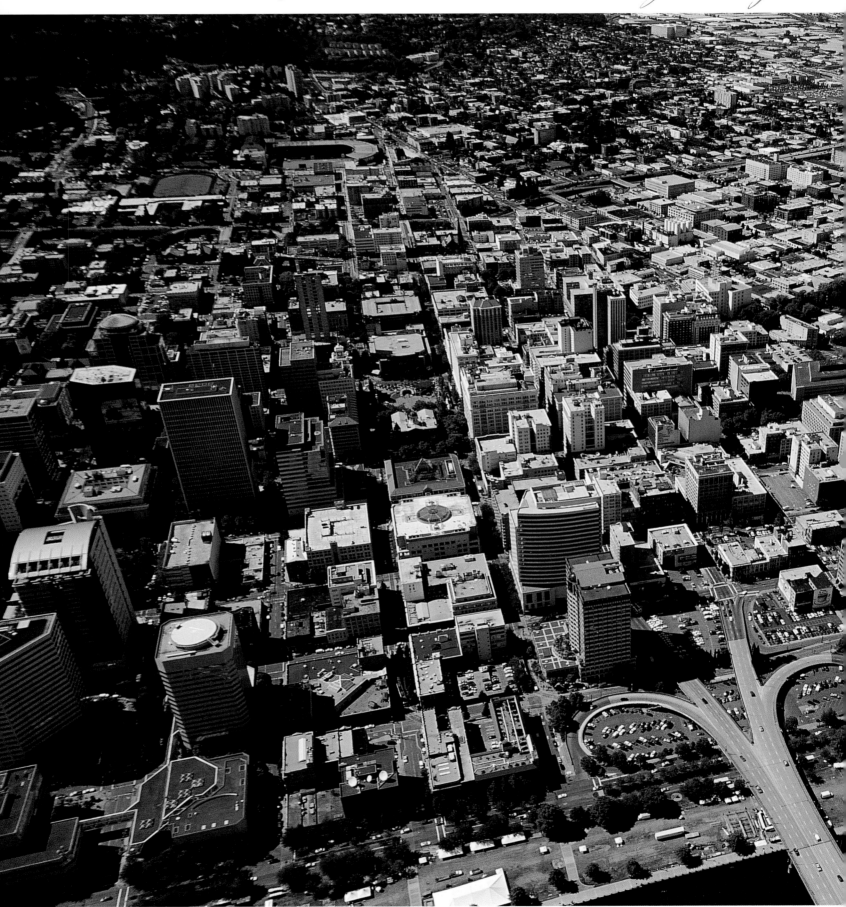

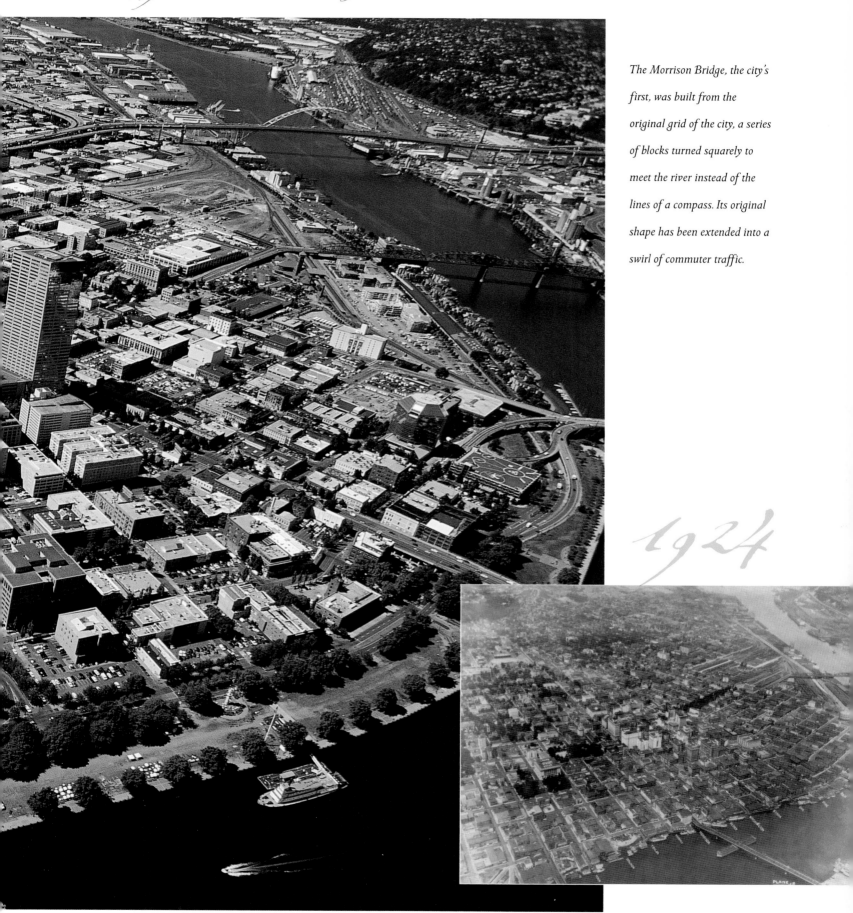

The Morrison Bridge, the city's
first, was built from the
original grid of the city, a series
of blocks turned squarely to
meet the river instead of the
lines of a compass. Its original
shape has been extended into a
swirl of commuter traffic.

1924

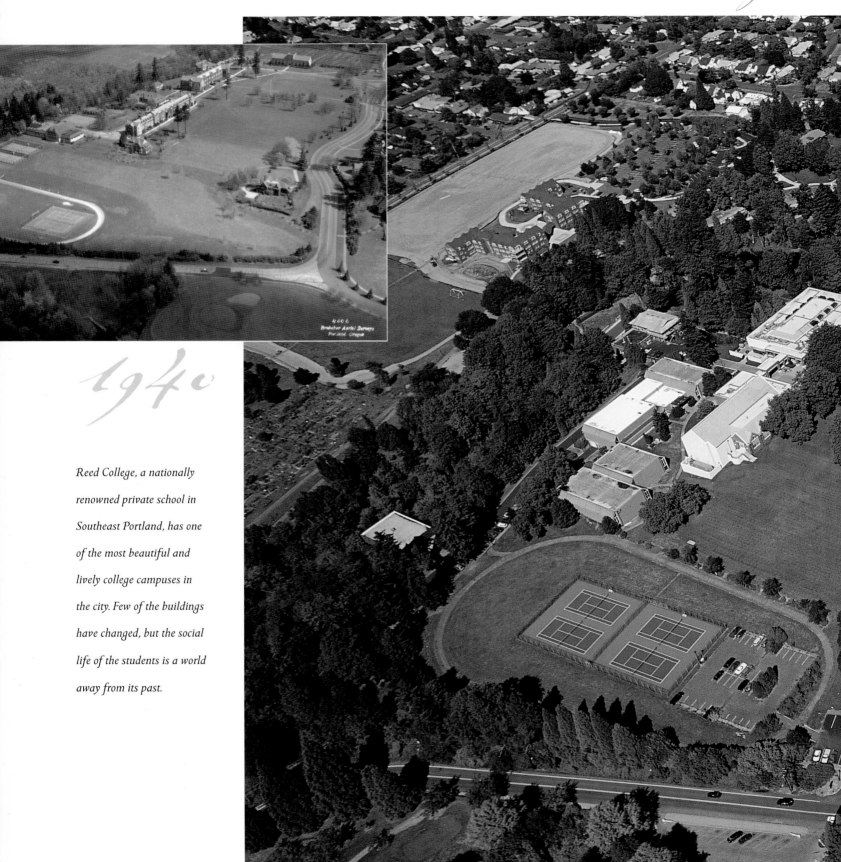

1940

Reed College, a nationally
renowned private school in
Southeast Portland, has one
of the most beautiful and
lively college campuses in
the city. Few of the buildings
have changed, but the social
life of the students is a world
away from its past.

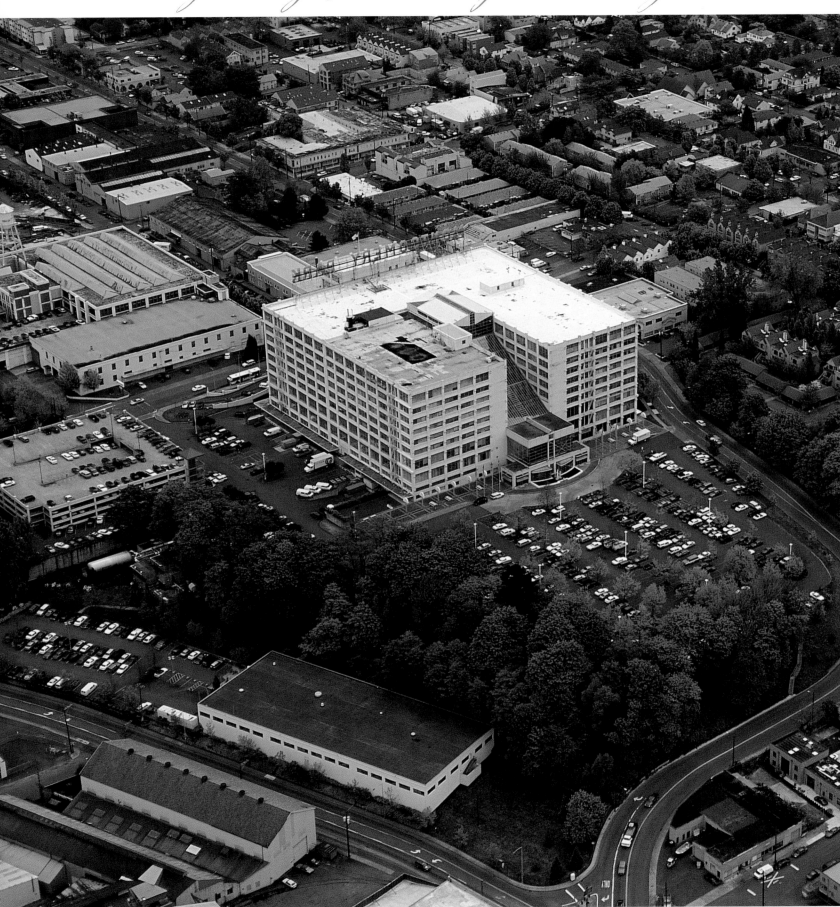

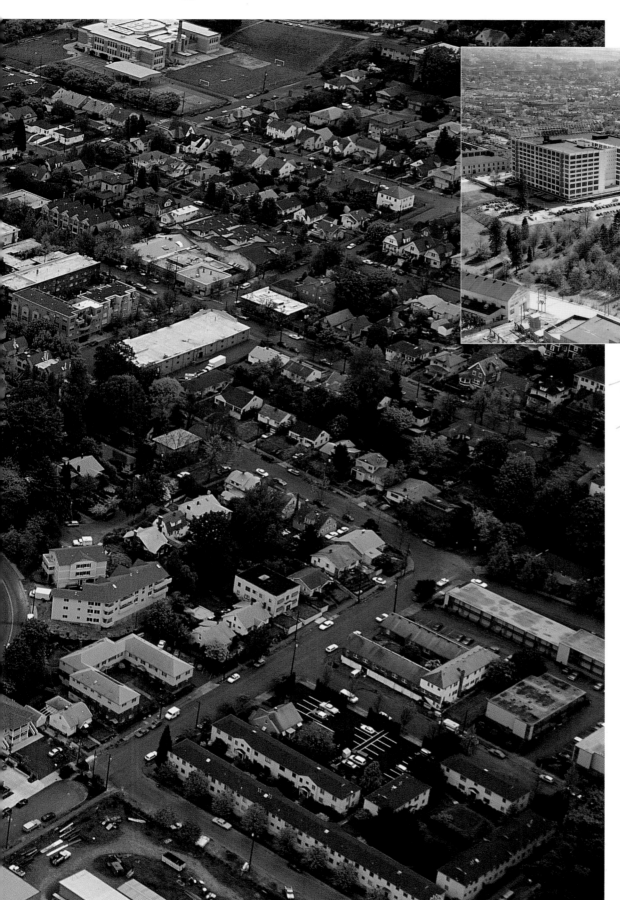

1940

The former department store in
the far corner of Northwest
Portland is now Montgomery
Park, home to an eclectic mix
of small businesses, including
several design and home
decorating showrooms.

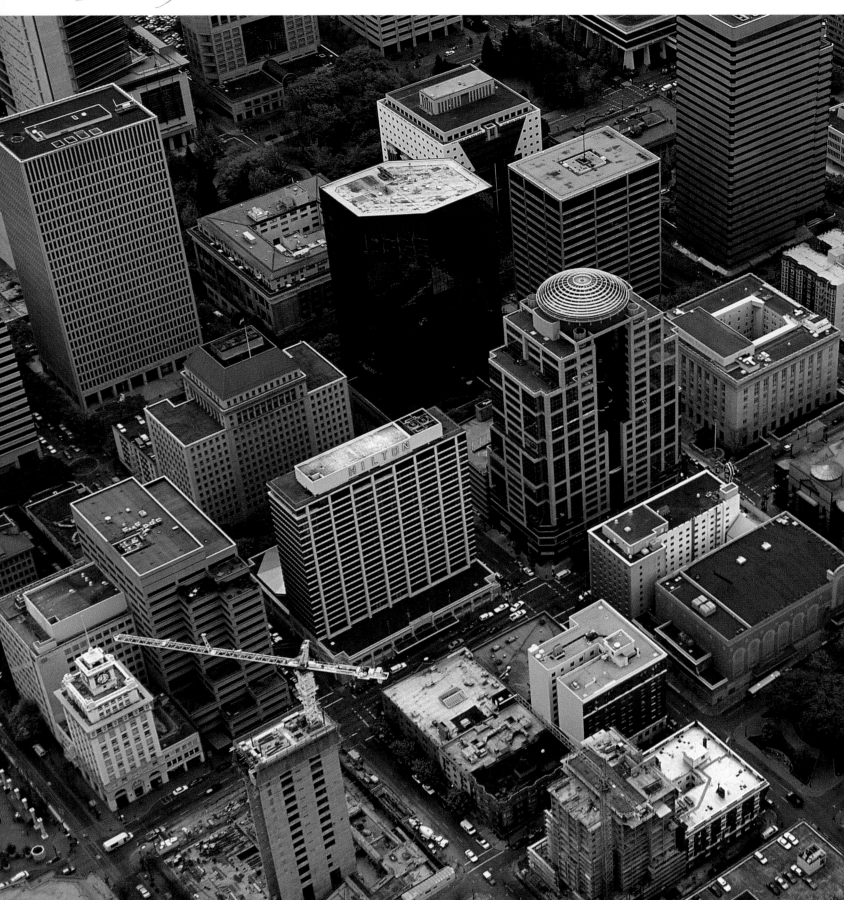

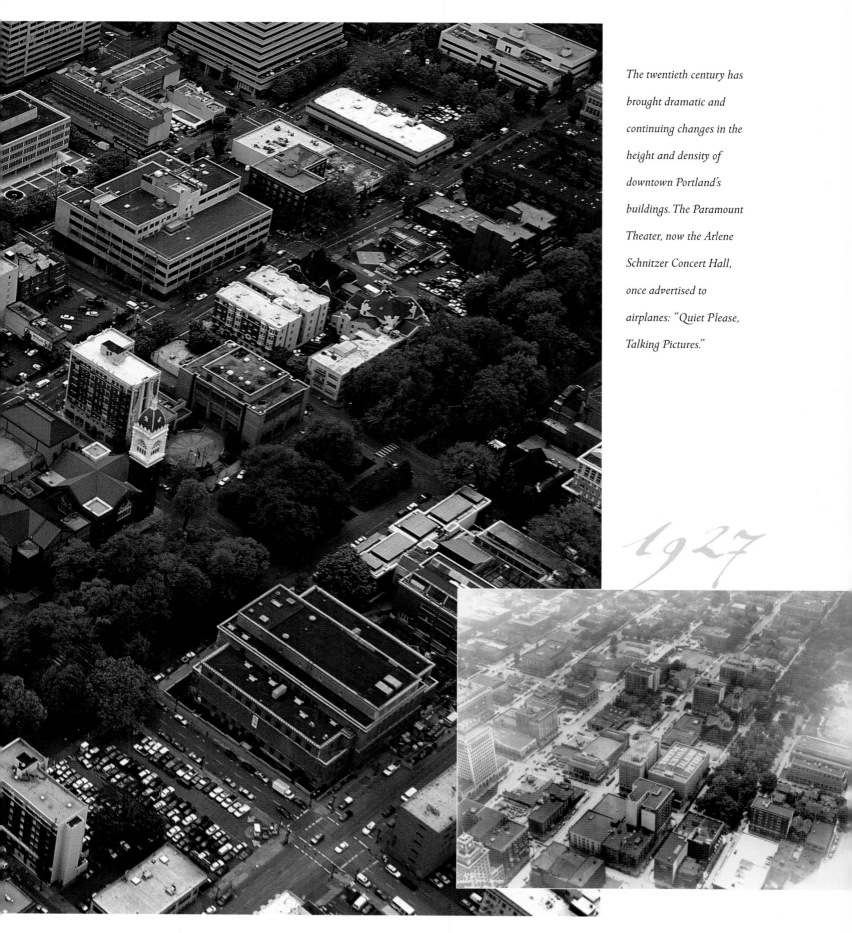

The twentieth century has brought dramatic and continuing changes in the height and density of downtown Portland's buildings. The Paramount Theater, now the Arlene Schnitzer Concert Hall, once advertised to airplanes: "Quiet Please, Talking Pictures."

1927

47

The formal gardens of the Lloyd Frank estate formed a strange oasis between stretches of forest. The Law School at Lewis and Clark College is one of the region's best.

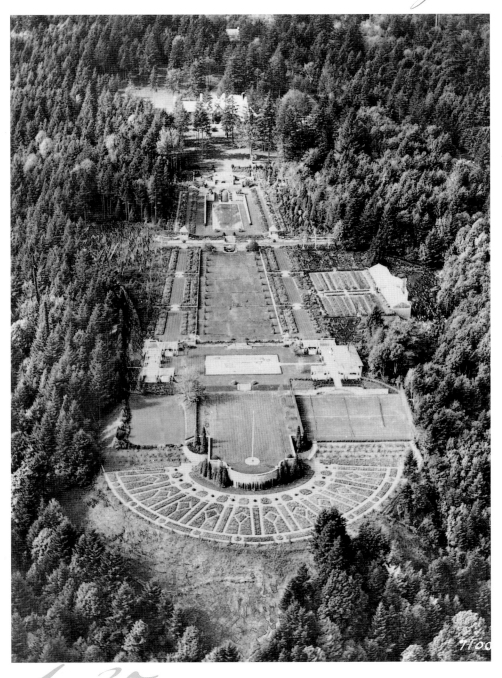

1927

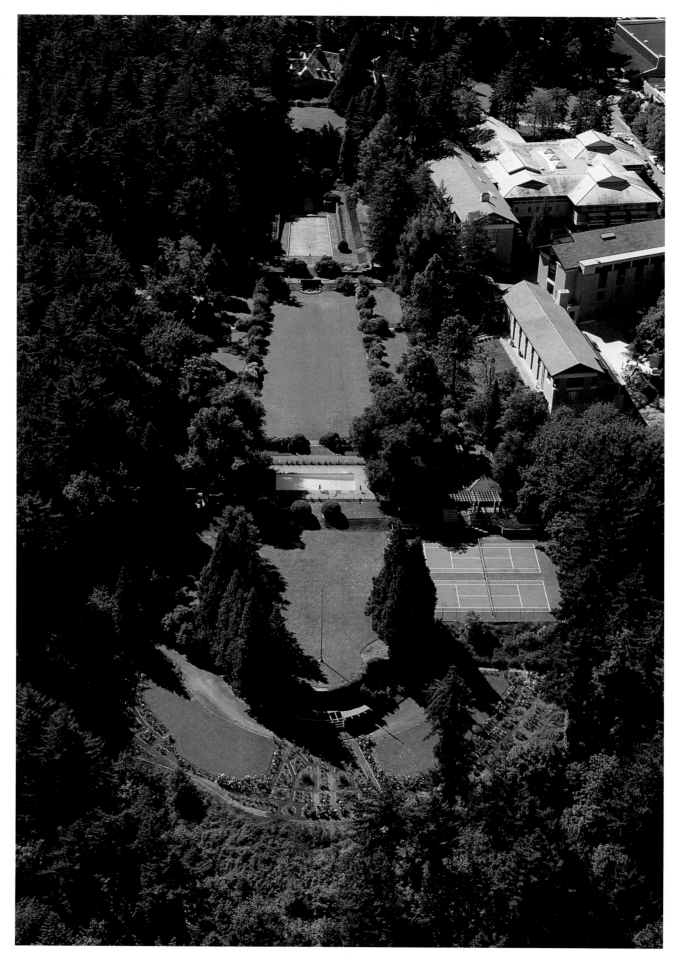

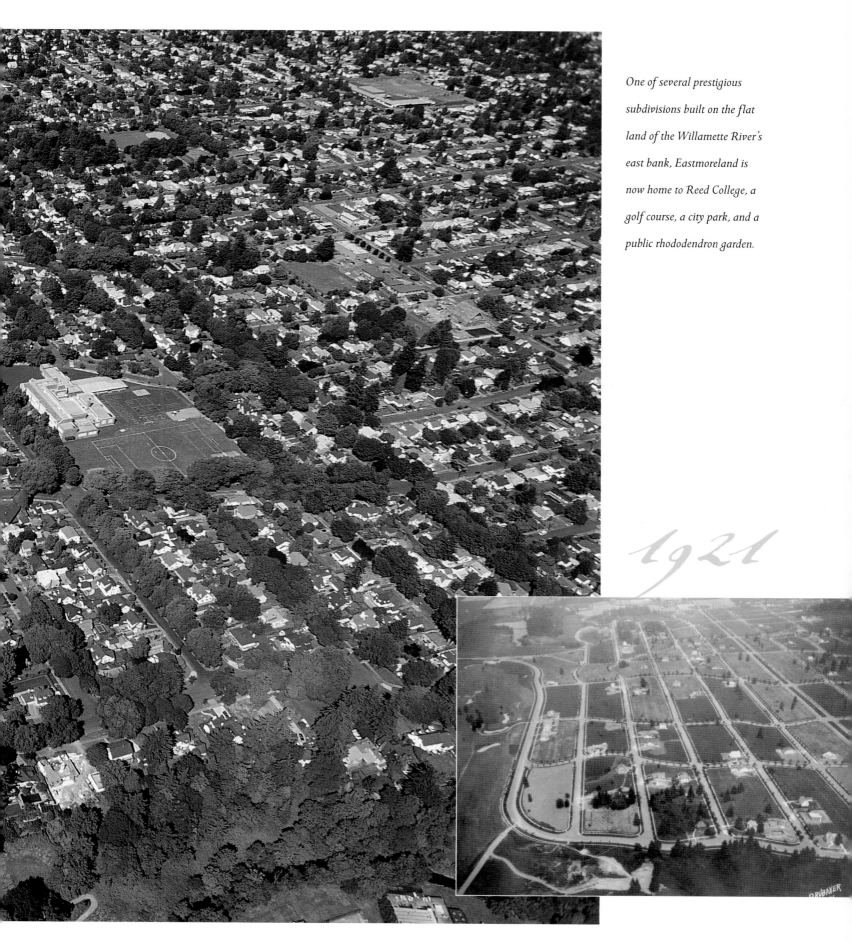

One of several prestigious
subdivisions built on the flat
land of the Willamette River's
east bank, Eastmoreland is
now home to Reed College, a
golf course, a city park, and a
public rhododendron garden.

1921

51

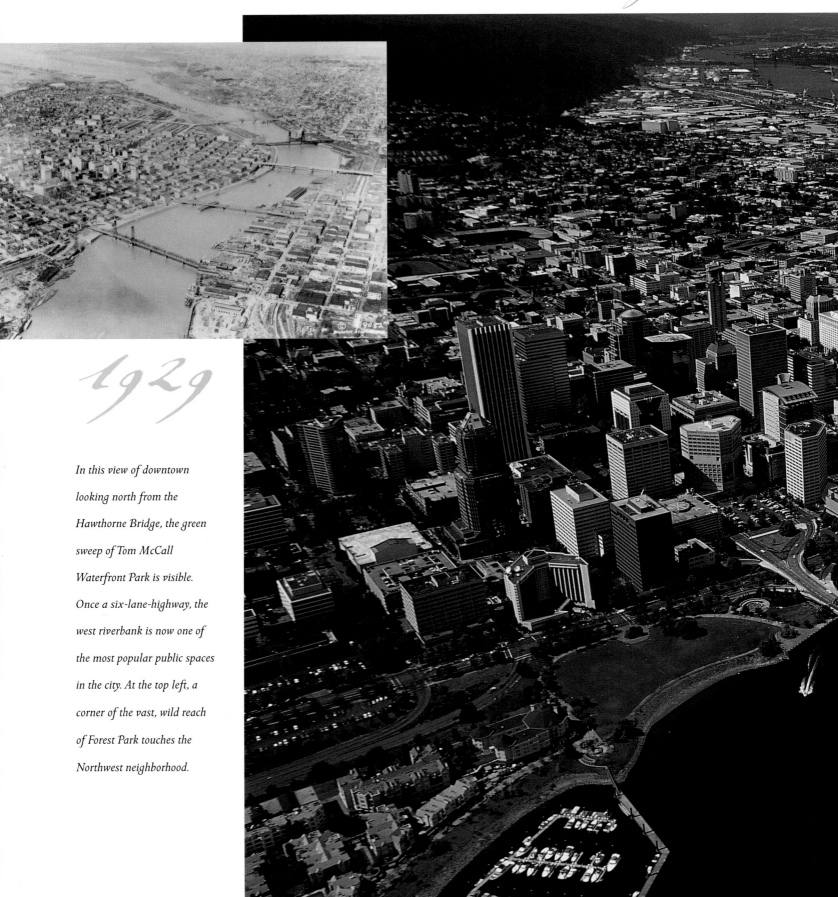

1929

In this view of downtown looking north from the Hawthorne Bridge, the green sweep of Tom McCall Waterfront Park is visible. Once a six-lane-highway, the west riverbank is now one of the most popular public spaces in the city. At the top left, a corner of the vast, wild reach of Forest Park touches the Northwest neighborhood.

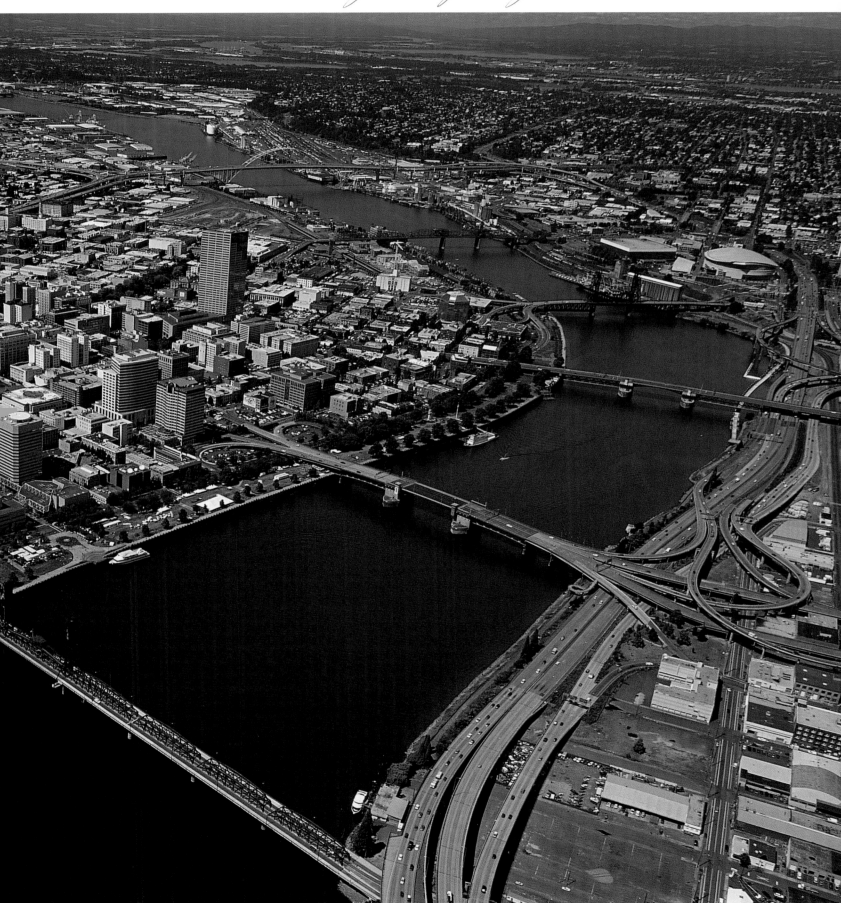

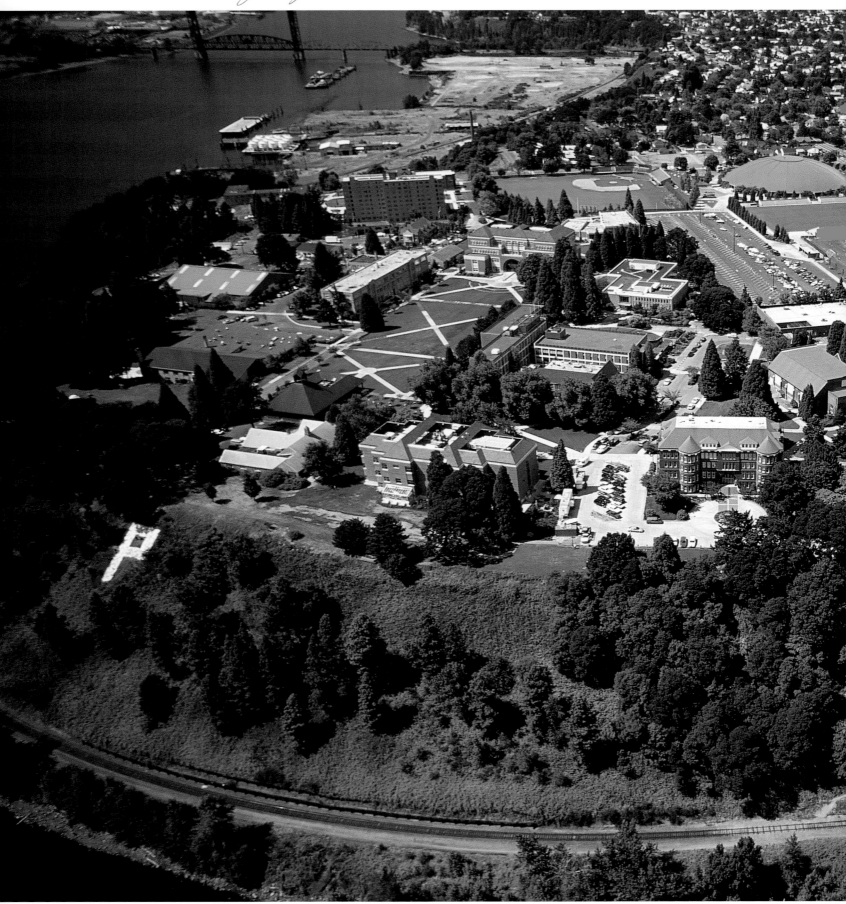

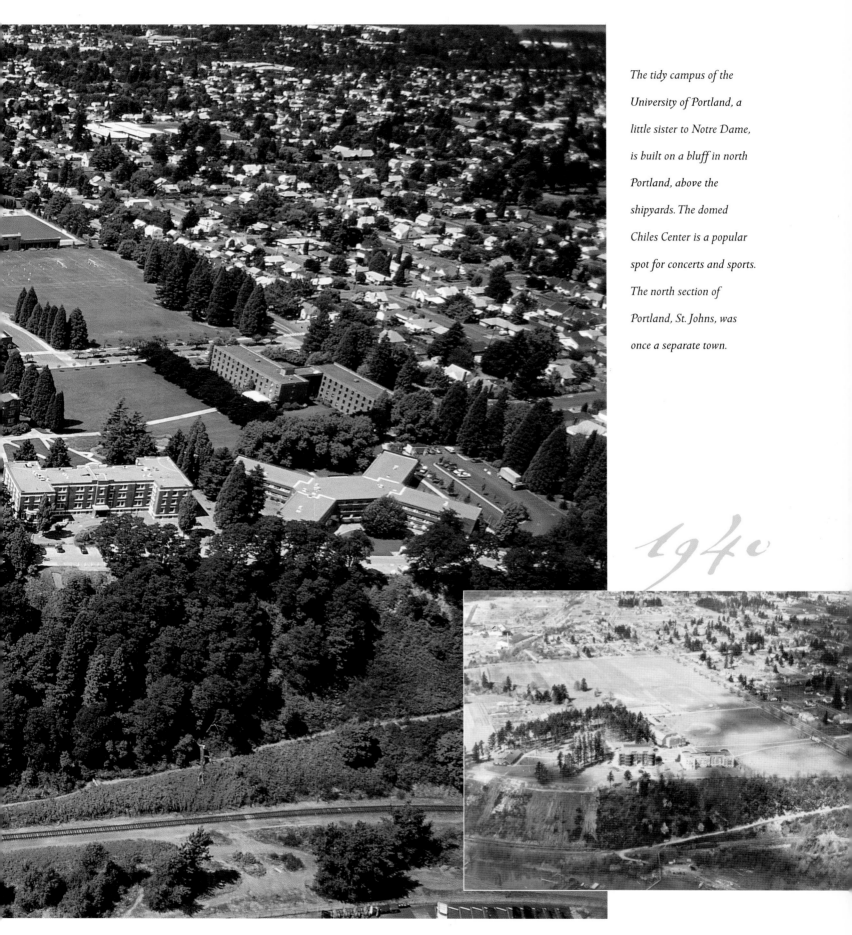

The tidy campus of the University of Portland, a little sister to Notre Dame, is built on a bluff in north Portland, above the shipyards. The domed Chiles Center is a popular spot for concerts and sports. The north section of Portland, St. Johns, was once a separate town.

1940

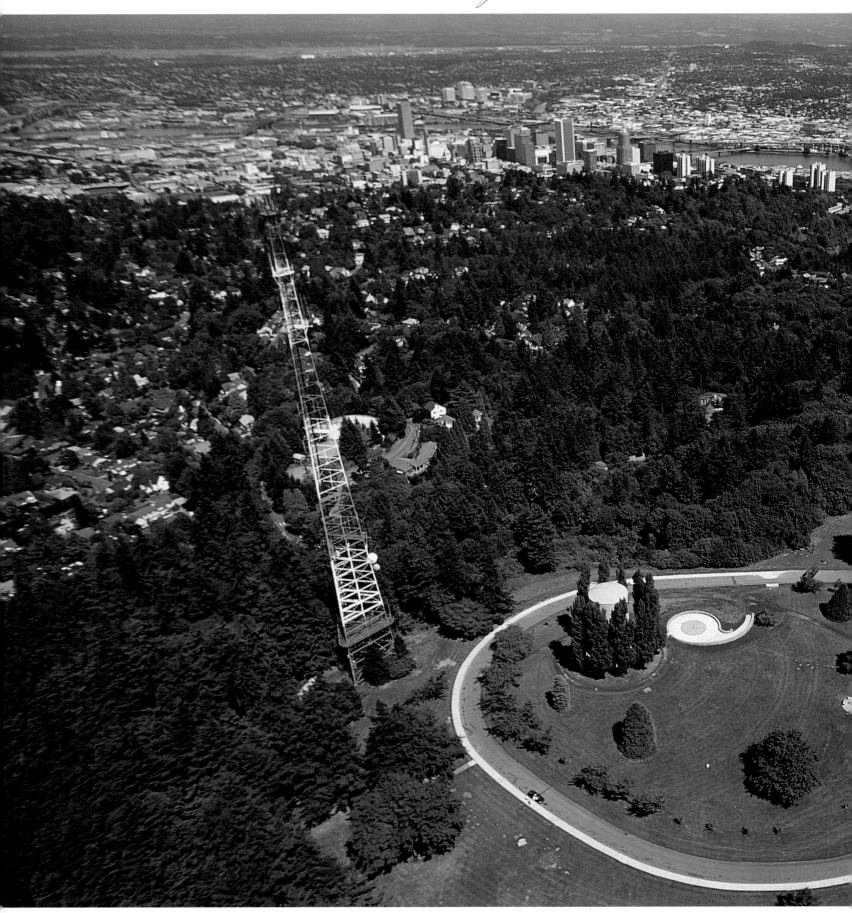

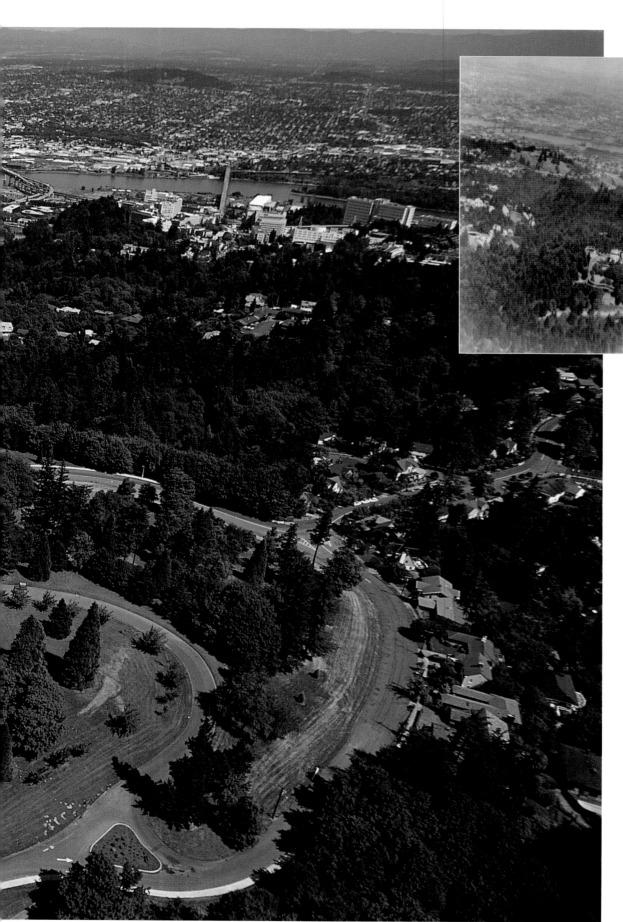

1929

Council Crest rises above the city. Once home to an amusement park, complete with roller-coaster, the wooded hill south of downtown is now the center of a fashionable neighborhood.

Portland

Old Town

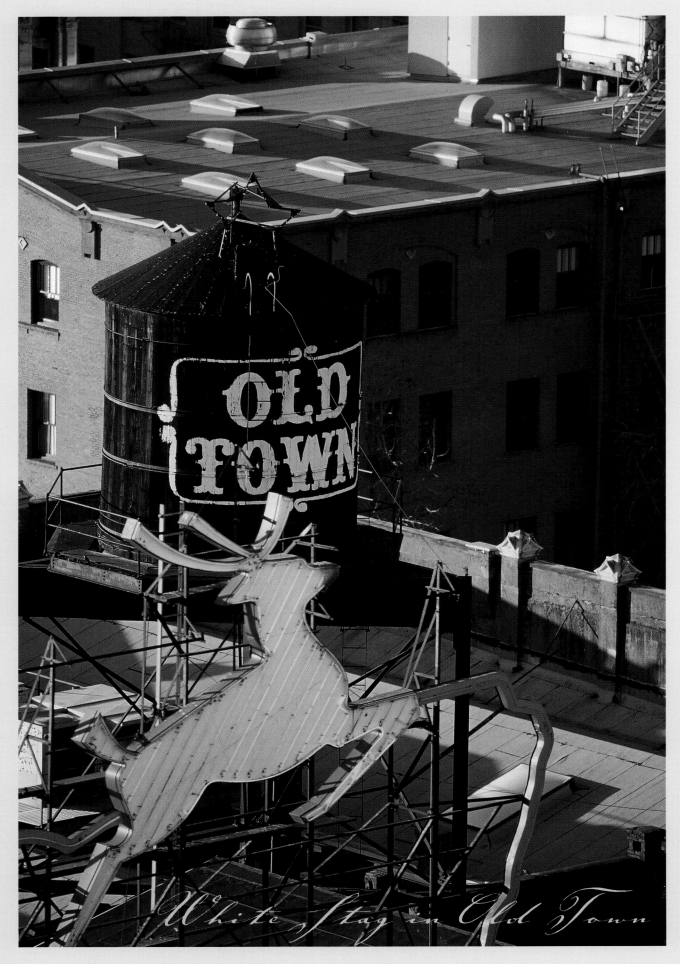

White Stag in Old Town

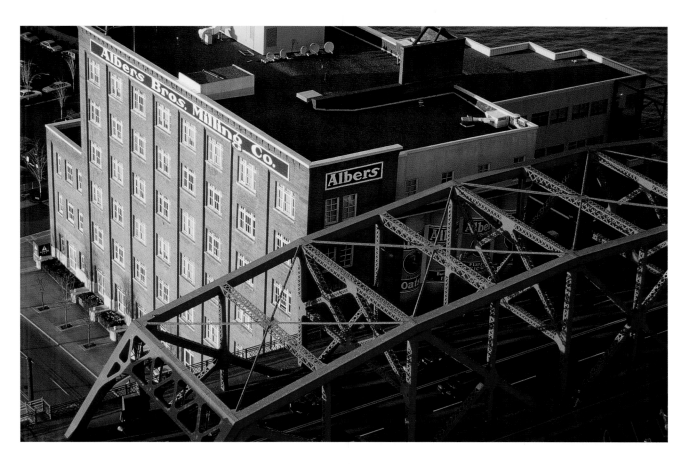

◄ *The White Stag still leaps beside the Burnside Bridge, though it now belongs to the Made In Oregon Company. Every December, the stag turns into a red-nosed Rudolph.* ▲ ▲ *The Albers Mill building next to the Broadway Bridge has been a landmark since 1911. Wheat is one of the treasures Portland has long depended upon.* ▲ *The State office building overlooks the Banfield Expressway in Northeast Portland.*

61

◄ *The Oregon Historical Society building houses a museum, gift shop, and important library of rare materials. Its* trompe l'oeil *mural is one of many public artworks on Portland streets.*

▶ *The spire of the First Congregational Church rises above the park blocks on one side and the busy Performing Arts Center next door.*

▶ ▶ *The Temple Beth Israel, completed in 1928, is considered one of the finest examples of Byzantine architecture in the Northwest.*

▶ ▶ ▶ *Consecrated on October 14, 1906, the Trinity Episcopal Cathedral serves more than 2,000 parishioners in Northwest Portland.*

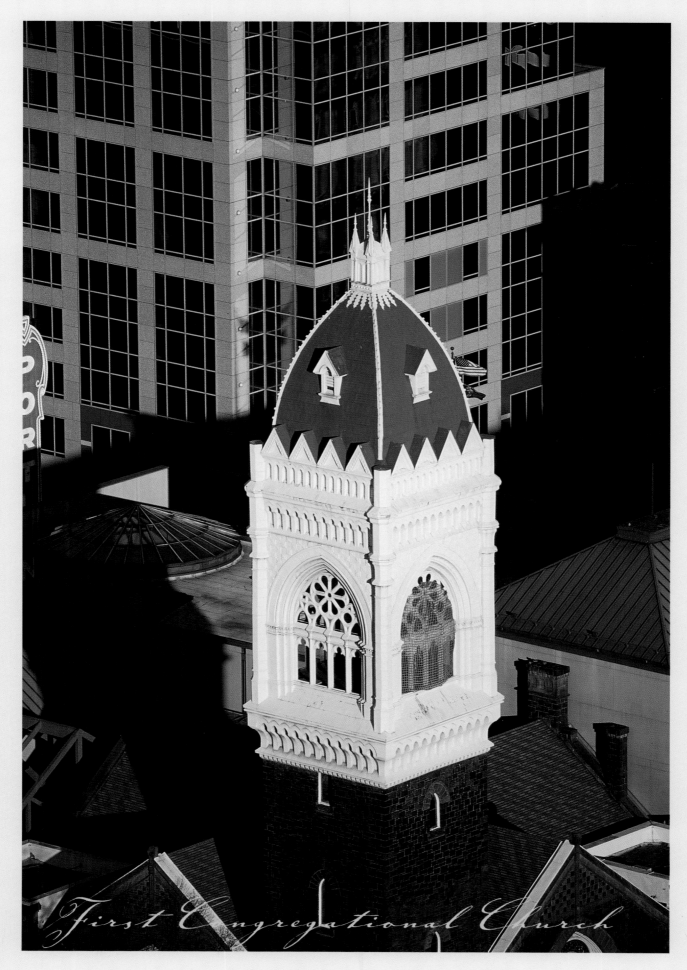

First Congregational Church

63

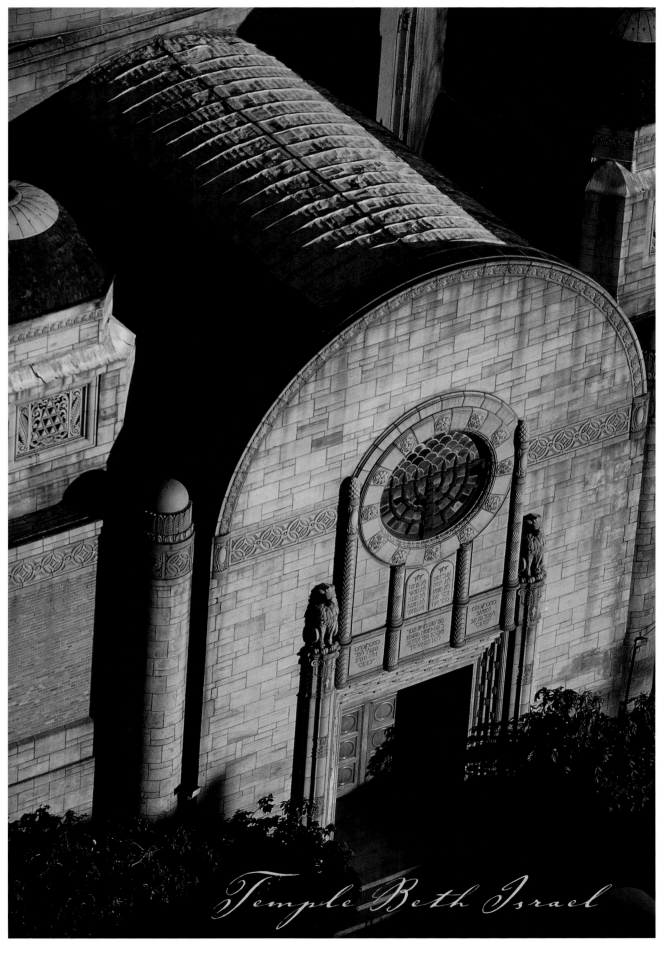

Temple Beth Israel

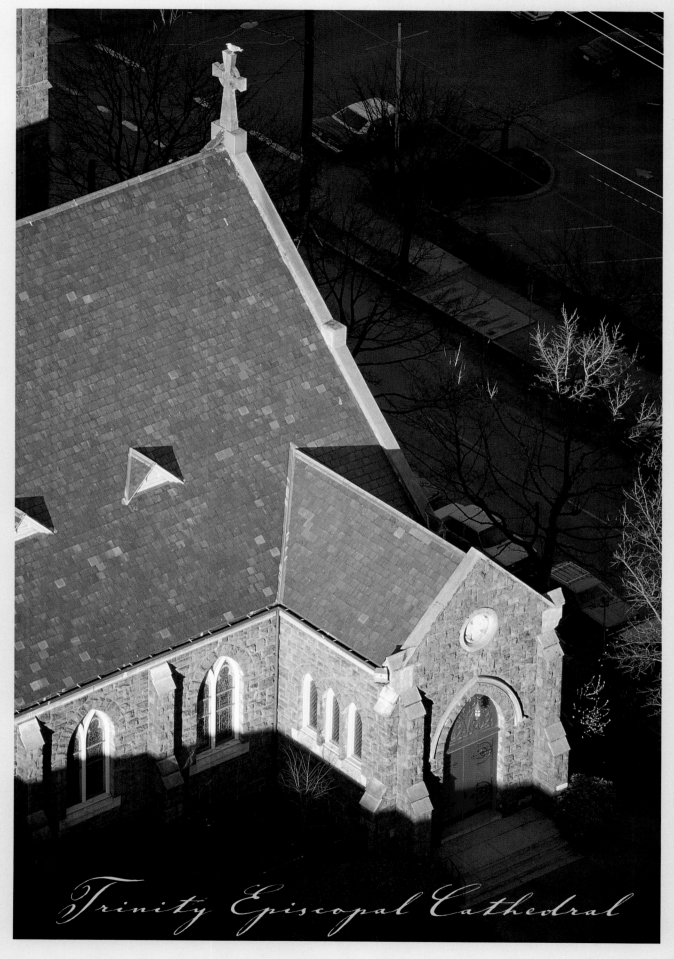

Trinity Episcopal Cathedral

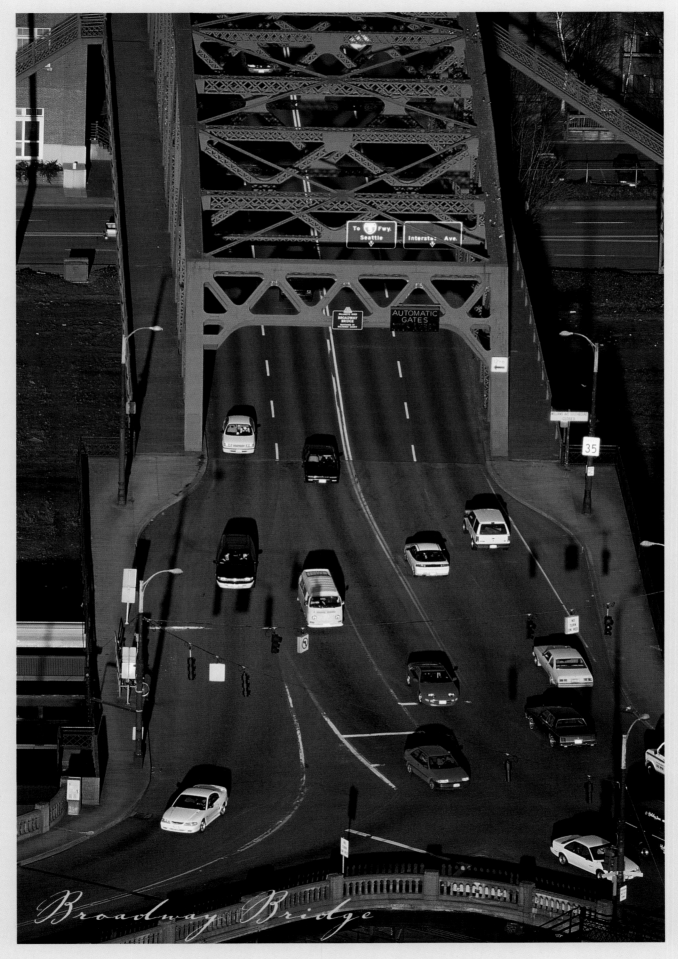

Broadway Bridge

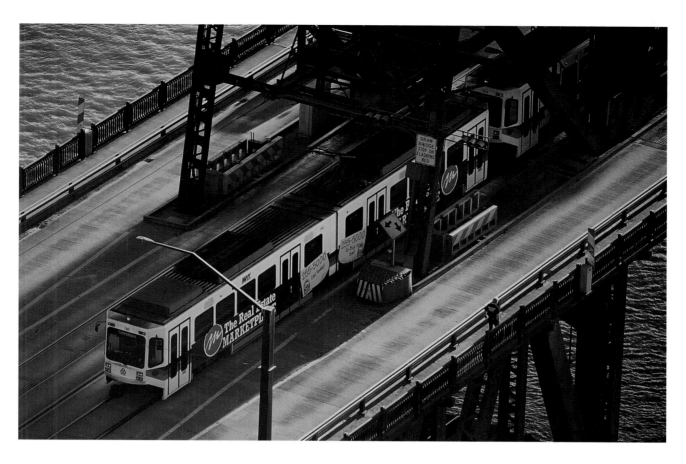

◀ *Portland once had nearly two hundred miles of train and streetcar tracks, forming a transporation web with ferries, carriages, horses, and pedestrians.* ▲▲ *Almost all the streetcar tracks were torn up by mid-century, but the modern light-rail train system is still growing.* ▲ *Freight trains pass through the city all hours of the day and night.*

Clipper ship

◄ *The* Lady Washington *clipper ship sails down the Columbia River.* ▲▲ *Traditional Chinese dragon boats race on the Willamette River every summer, many of them with distinctly contemporary crews.* ▲ *The USS* Blueback *at the Oregon Museum of Science and Industry (OMSI) was featured in the film* The Hunt for Red October.

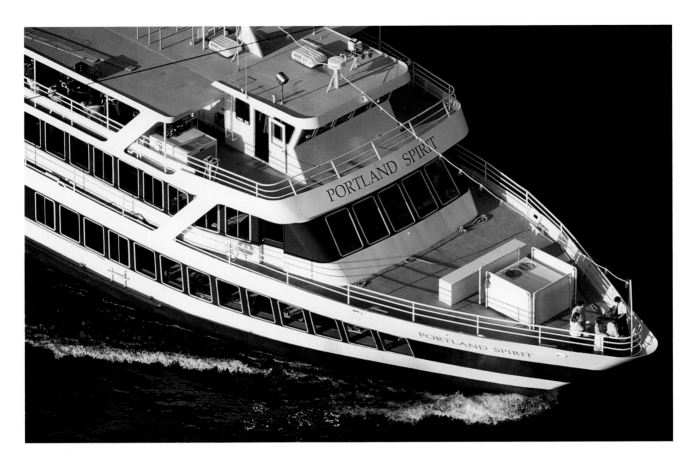

▲ ▲ *The* Portland Spirit *is one of several private sightseeing boats touring the Willamette and Columbia Rivers.* ▲ *South of Waterfront Park, the RiverPlace development has added riverside housing, bike and walking paths, a marina, and restaurants, like the Newport Bay.*

▶ *Grain, and especially wheat, was one of the keys to Portland's expansion. Barges bring crops from eastern Oregon and Washington down hundreds of miles of river to be loaded onto grain ships like this one for export overseas.*

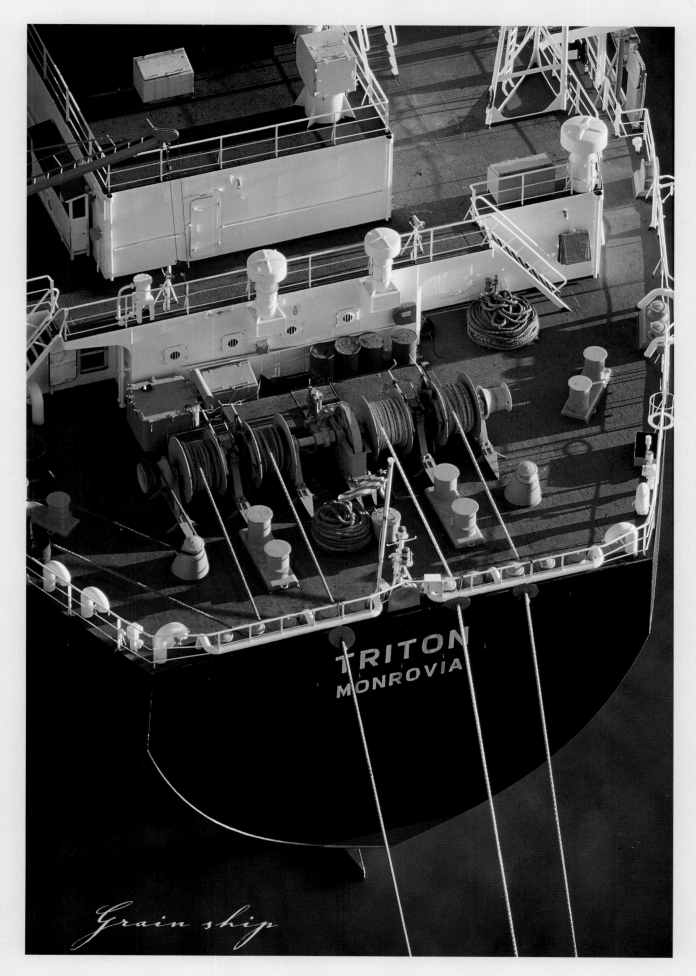

Grain ship

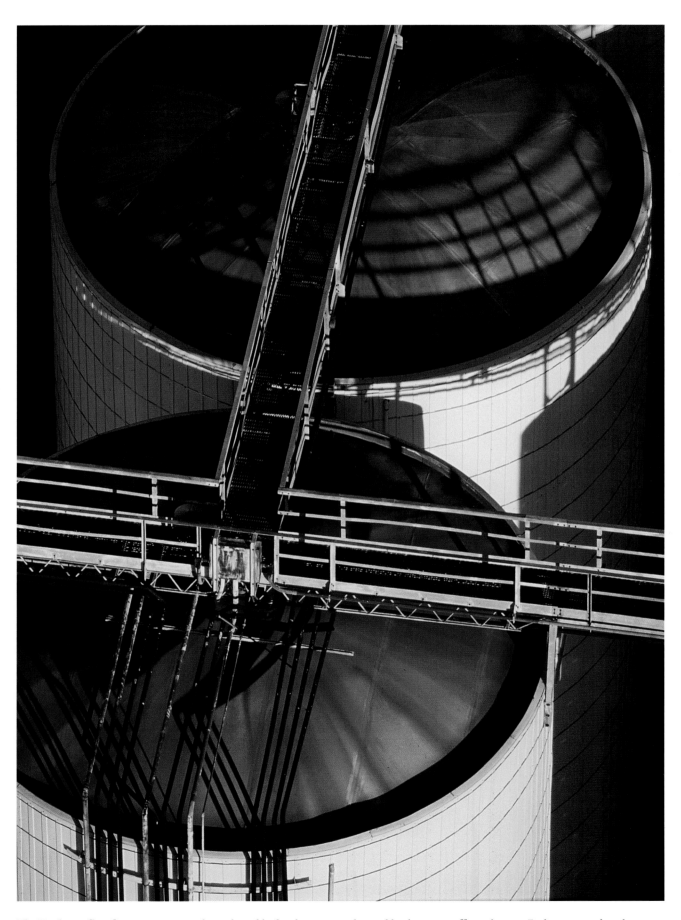

The Northwest flats form an intricate industrial neighborhood, serving and served by the river traffic and trains. Fuel storage tanks, silos,

trucking companies, and the many tasks of an international shipping and repair center keep the area busy 24 hours a day.

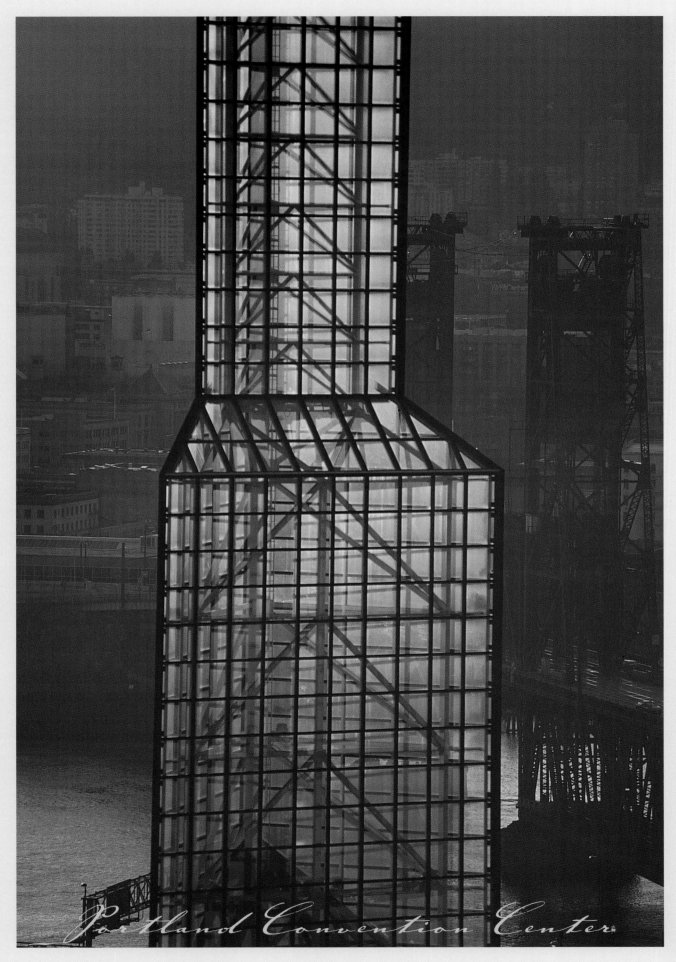

Portland Convention Center

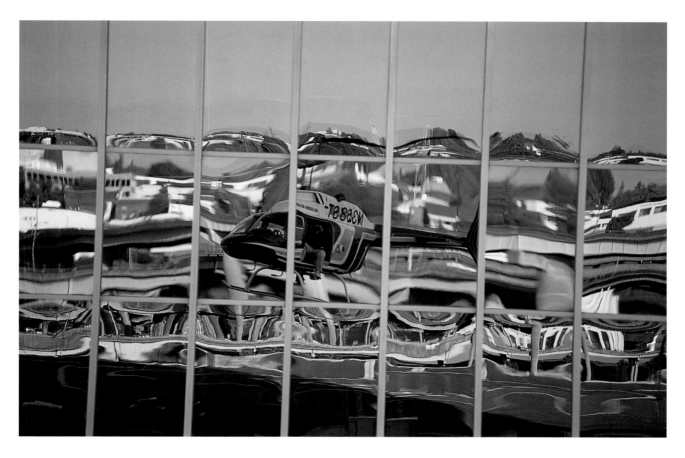

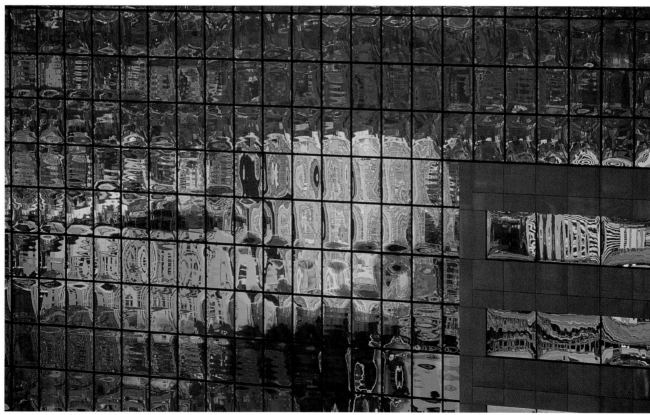

◄ *The twin glass towers of the Convention Center were originally built as scaffolding, to be taken down when the building was done. They proved to be too beautiful for that fate.* ▲ *The mirrored glass of Security Pacific Plaza creates a shimmering perspective to the city—and to the photographer.*

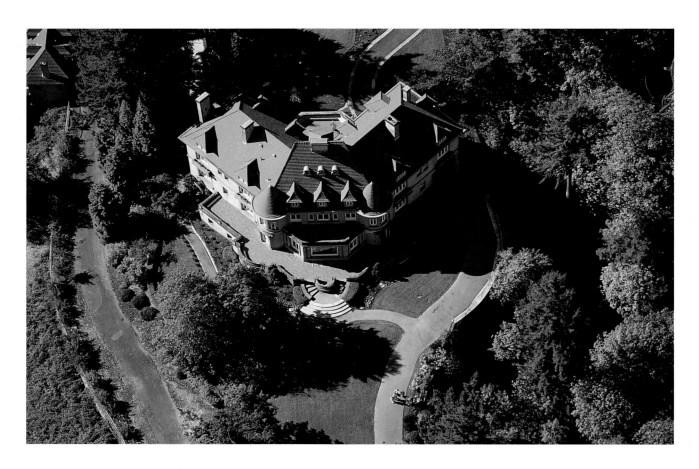

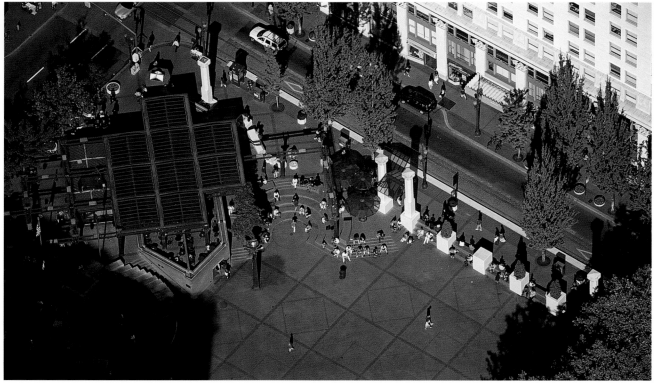

▲ ▲ *The Pittock Mansion, built on a bluff above the city, is now a museum for an extinct world of Victorian social registers.* ▲ *In contrast, Pioneer Square, with its etched bricks and spontaneous public entertainment, is a living room for the entire city.* ▶ *The waffle sole was invented by University of Oregon track coach Bill Bowerman, using his patient wife's waffle iron. Those kitchen experiments led to the Nike empire, and the sprawling corporate campus west of Portland.*

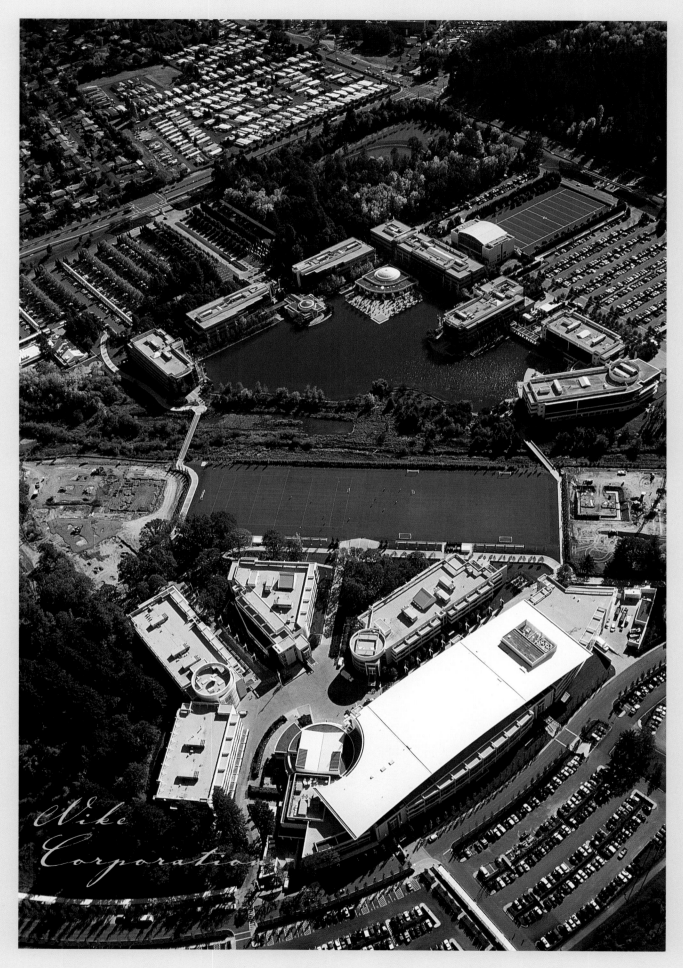

Nike Corporation

Day Trips

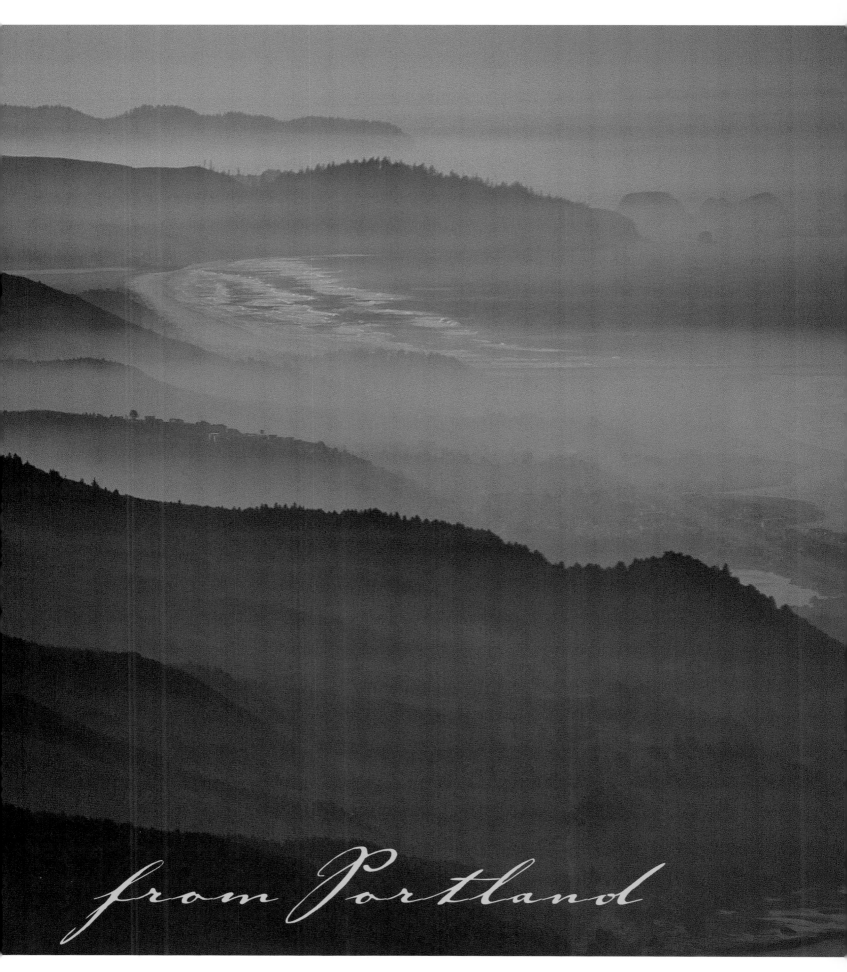

from Portland

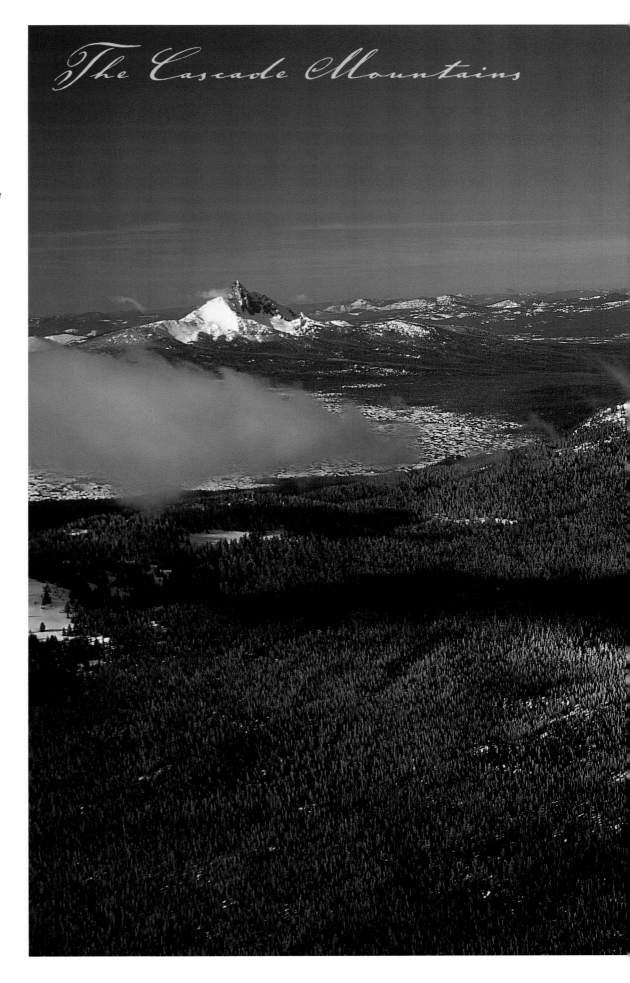

The Cascade Mountains

▶ *From the Canadian border into Northern California, an active chain of volcanoes known as the Cascades forms a wavering line of peaks—from the intimidating masses of Rainier and Baker to the delicate pitch of Jefferson to Shasta's maternal heft. The mountains seem eternal and yet are never the same, changing with every shift in light and shadow.*

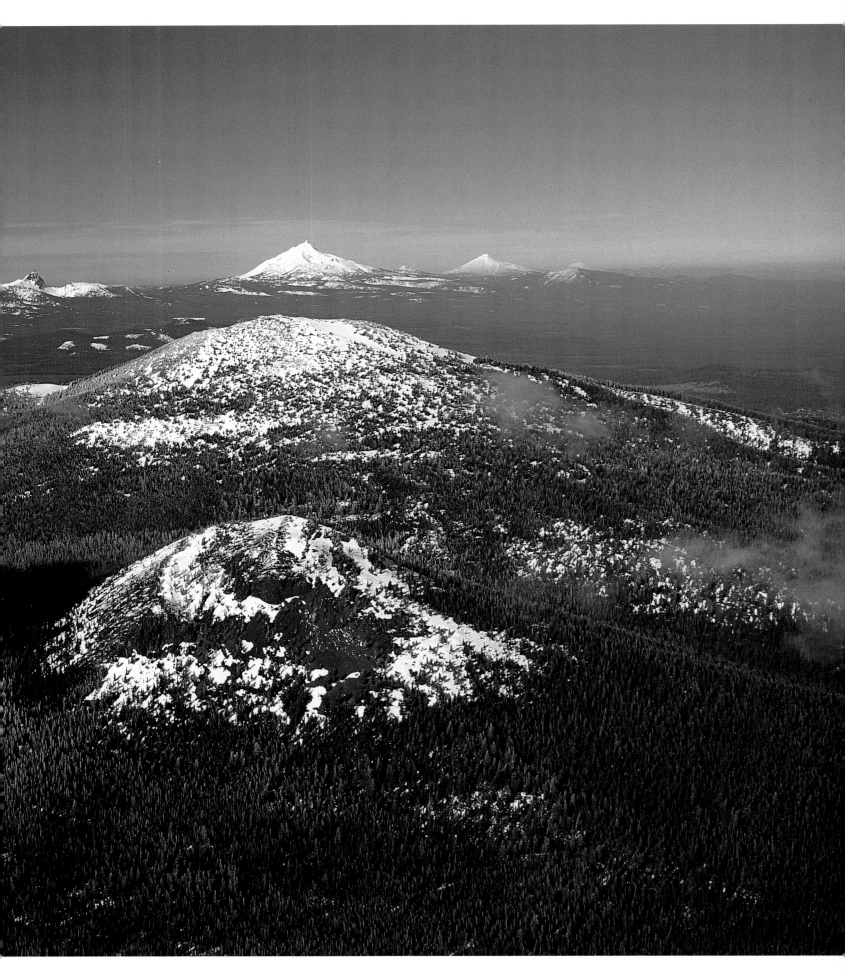

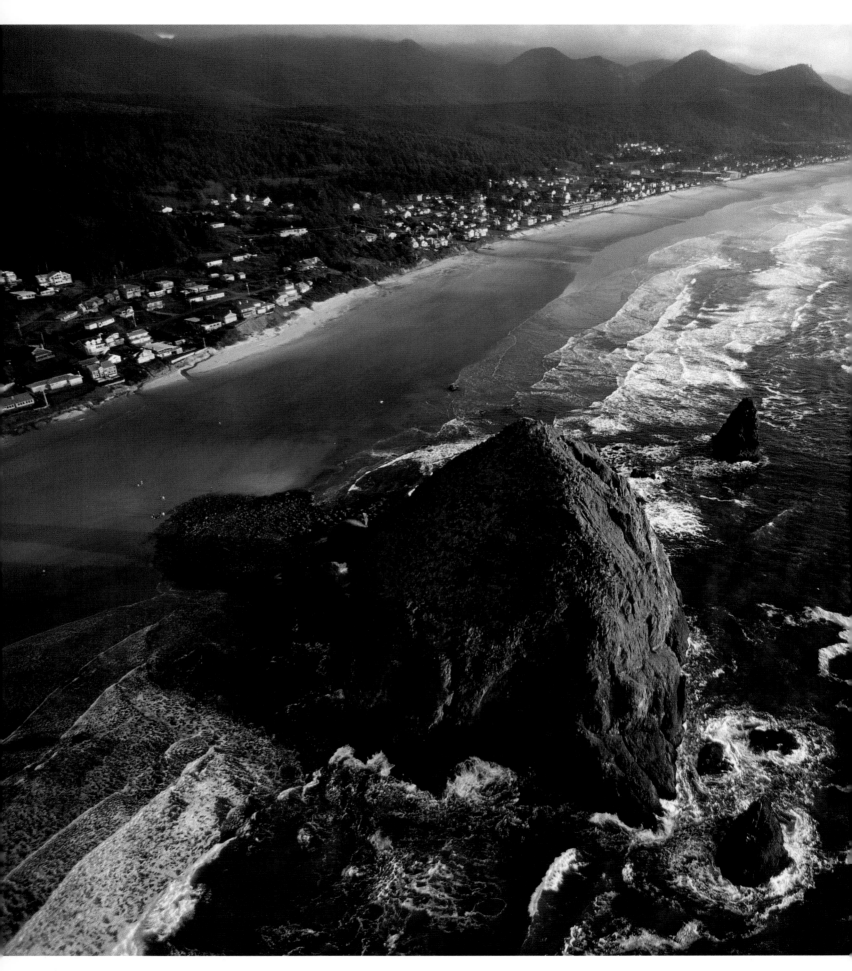

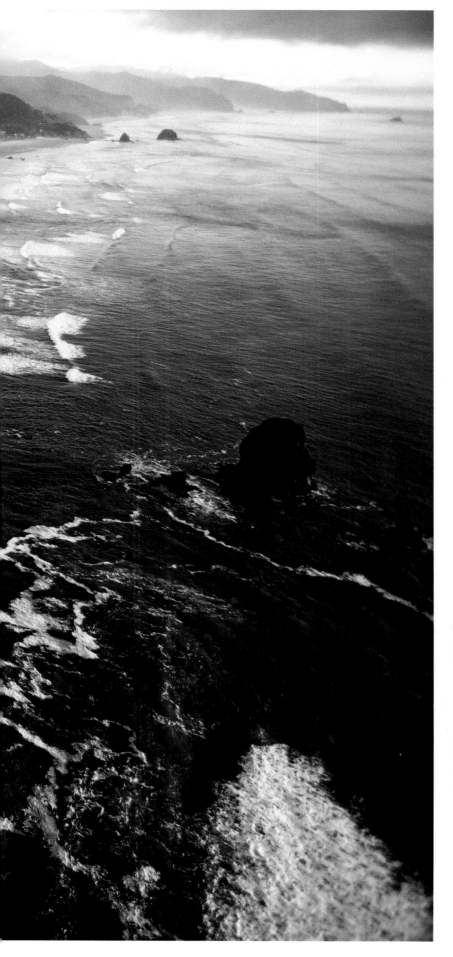

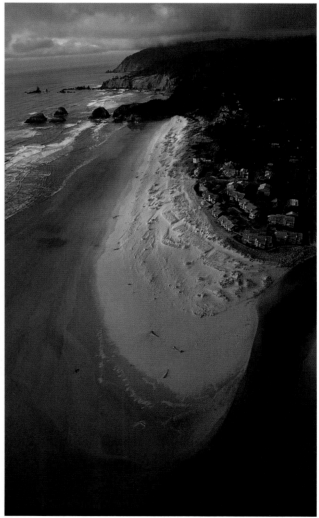

Portlanders visit the coast, little more than an hour away, in every season, to watch storms, whales, and kites. Oregonians share a public beach that stretches the entire length of the state. Cannon Beach, with its enormous Haystack Rock, is one of the state's most lovely stretches.

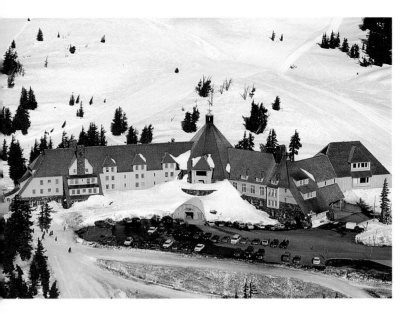

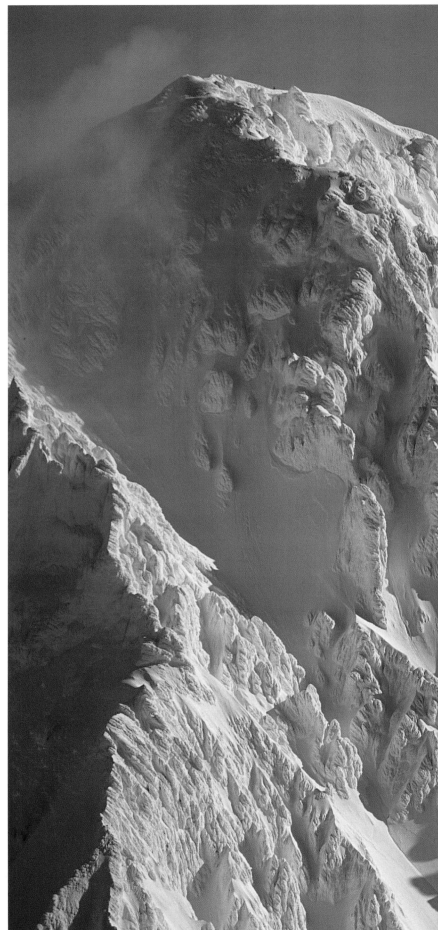

▲ *A 1930s WPA (Works Progress Administration) project,*
Timberline Lodge was built from raw timbers and stone by expert
craftsmen and artisans. The lodge is filled with skiers, snowboarders,
climbers, hikers, and the occasional idler throughout the year.

▶ *Mount Hood's weather is famously unpredictable. The sharp peak*
has been climbed by children and by women wearing high heels;
it has also killed dozens of people caught in sudden storms
and avalanches.

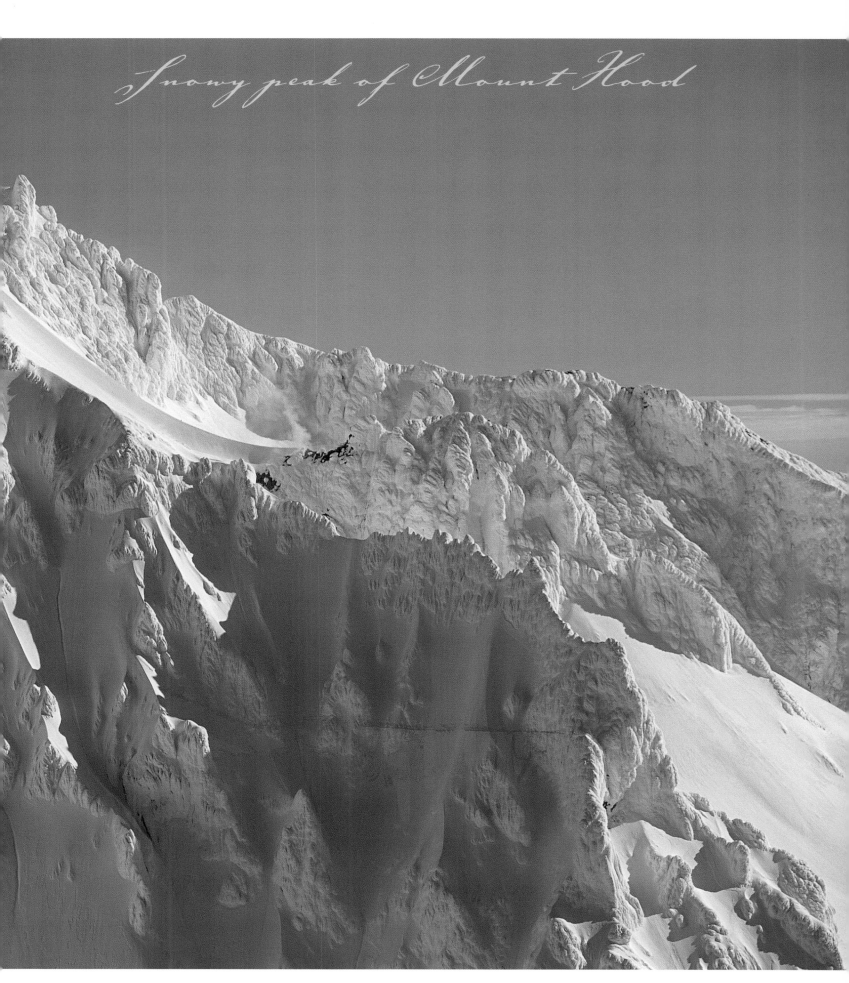

Snowy peak of Mount Hood

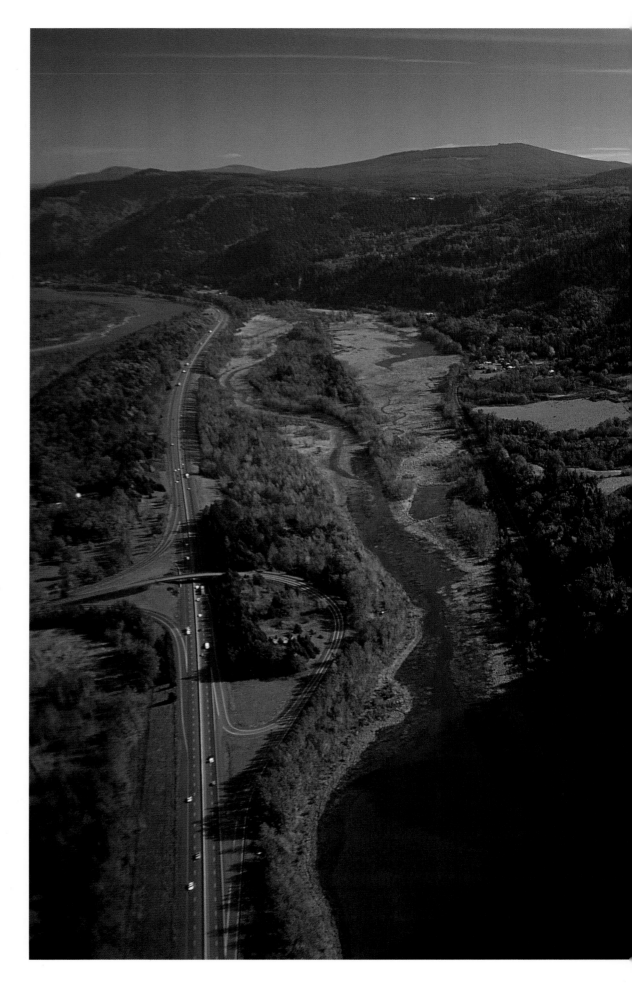

► *The Columbia Gorge, the only designated National Scenic Area in the country, begins just east of Portland. Interstate 84 hugs the river. Vista House, a 1916 landmark, was long accessible only by the old Columbia Gorge Highway, which was cut through the cliffs in one of the great engineering feats of the century.*

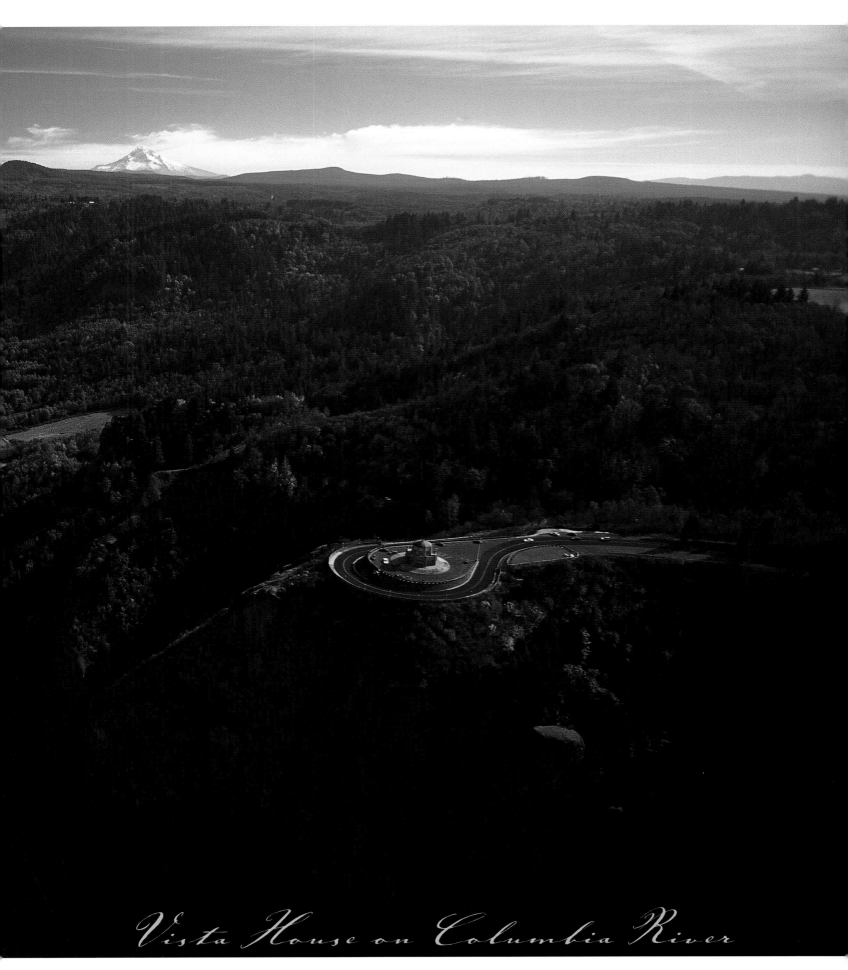

Vista House on Columbia River

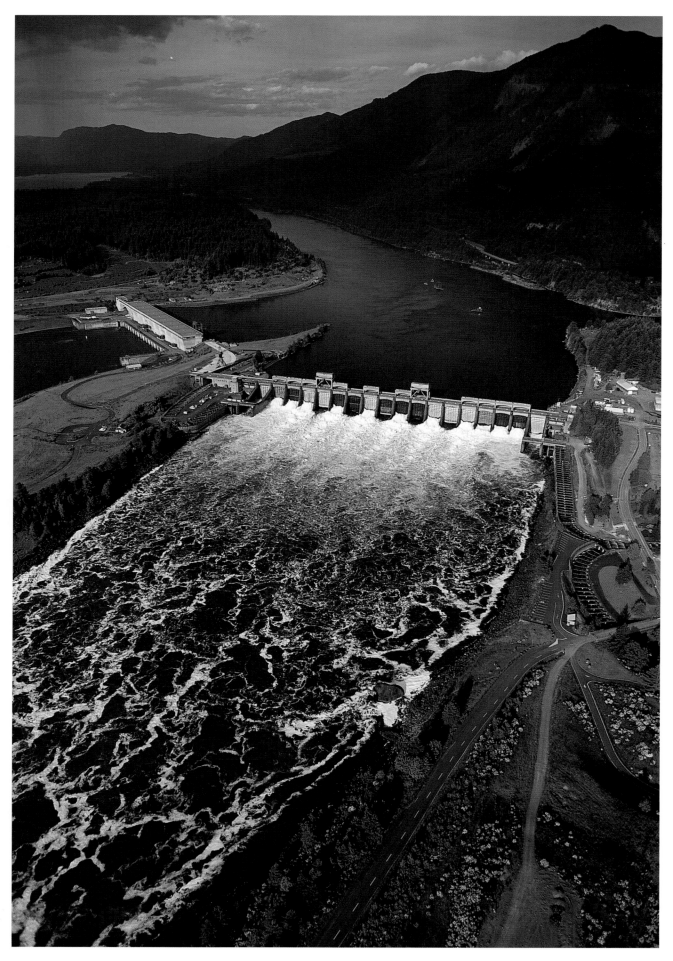

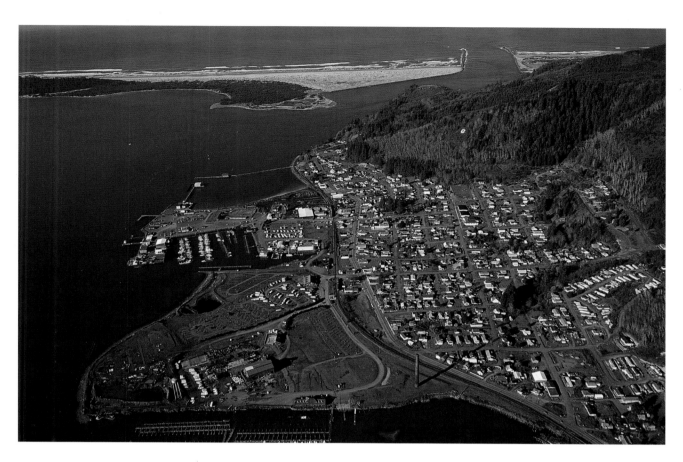

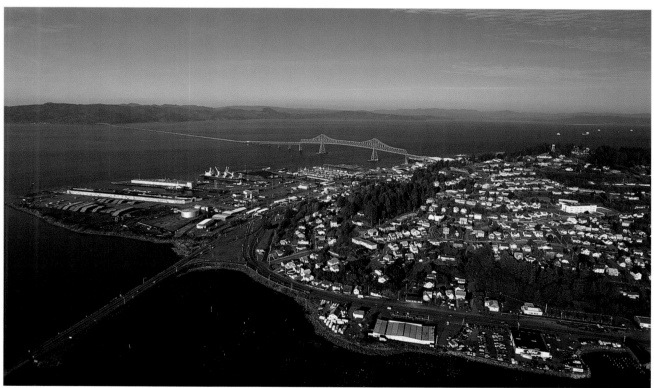

◄ *The massive Bonneville Dam spans the Columbia River east of Portland.* ▲▲ *Now a vacation destination, Garibaldi was originally a Tillamook Indian whaling village and, later, a major lumber shipping port.* ▲ *The small city of Astoria, in Oregon's northwesternmost corner, faces the state of Washington to the north, across the Columbia, and the river's mouth, which has one of the most treacherous sandbars in the United States.*

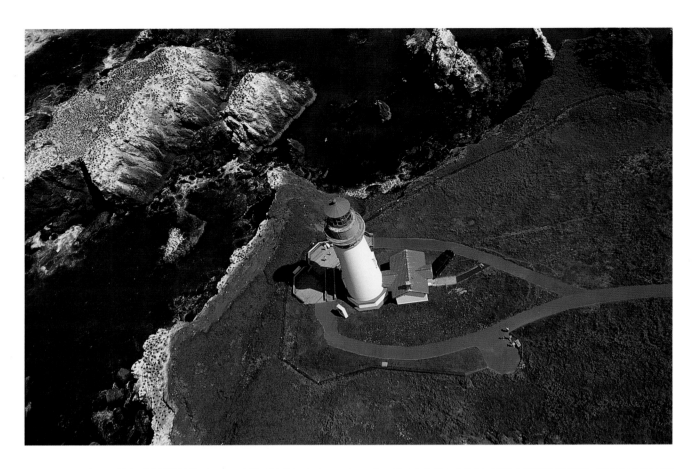

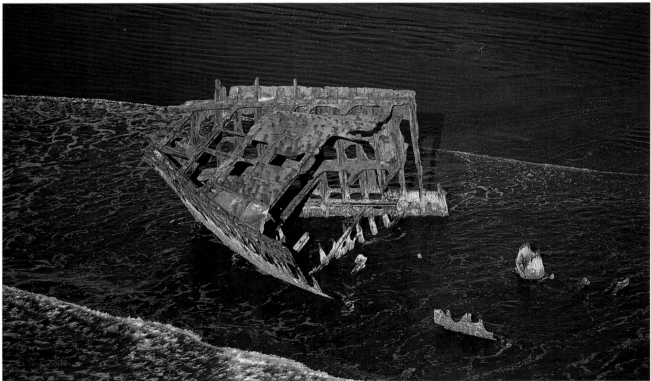

▲ ▲ *The Yaquina Head lighthouse is the tallest in Oregon, one of many lighthouses along the unpredictable shores of the Oregon coast. This wild shore is a favorite for whale-watchers.* ▲ *A crumbling shipwreck at the Fort Stevens State Park on the northern coast is an unusual attraction for land-based tourists..* ▶ *Oregon City was built on a series of bluffs above Willamette Falls, a wide rush of water once thought to be the key to creating a northwest metropolis.*

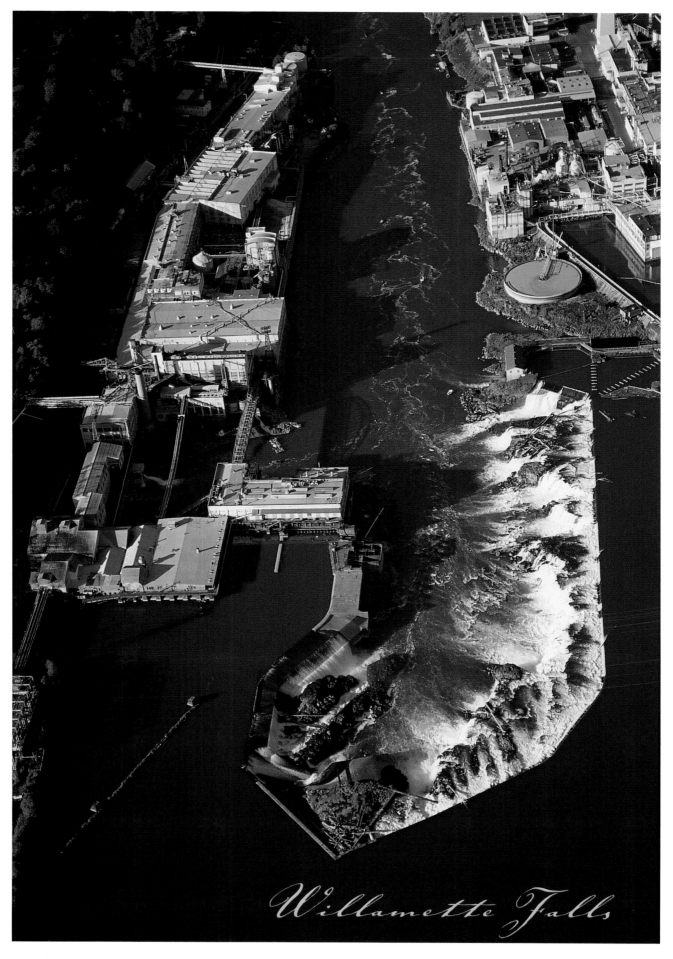

Willamette Falls

▲ *Monkeyface, at Smith Rocks State Park in Central Oregon, is one of a series of world-class climbing destinations in the Northwest.*

▶ *The western end of the Columbia Gorge is filled with dozens of waterfalls, some hidden from drivers and others, like Multnomah Falls,*

the tallest in the Gorge, visible to all who pass by.

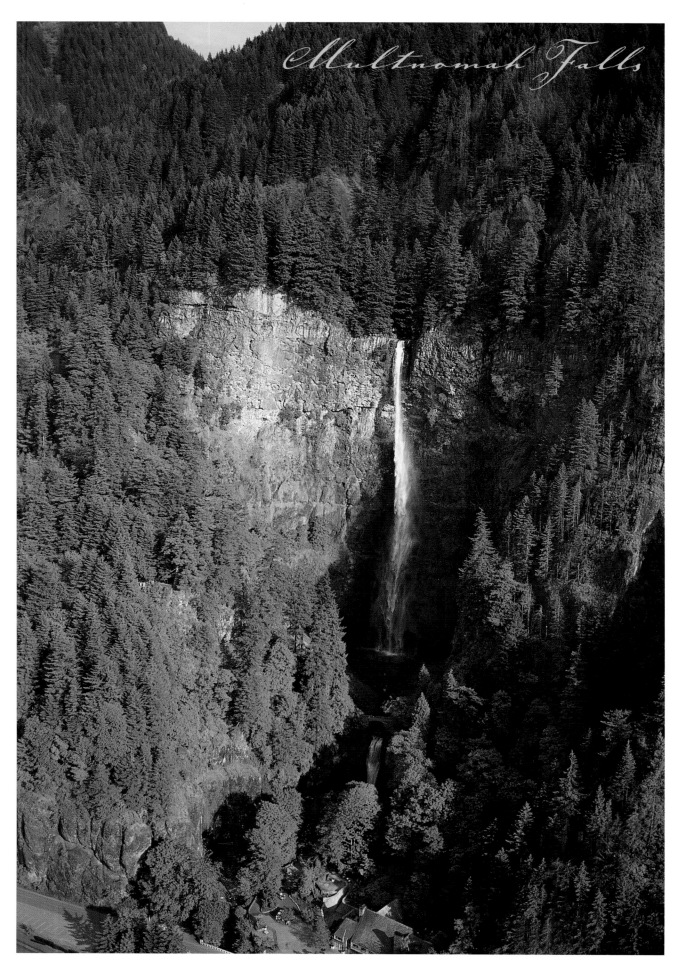

Multnomah Falls

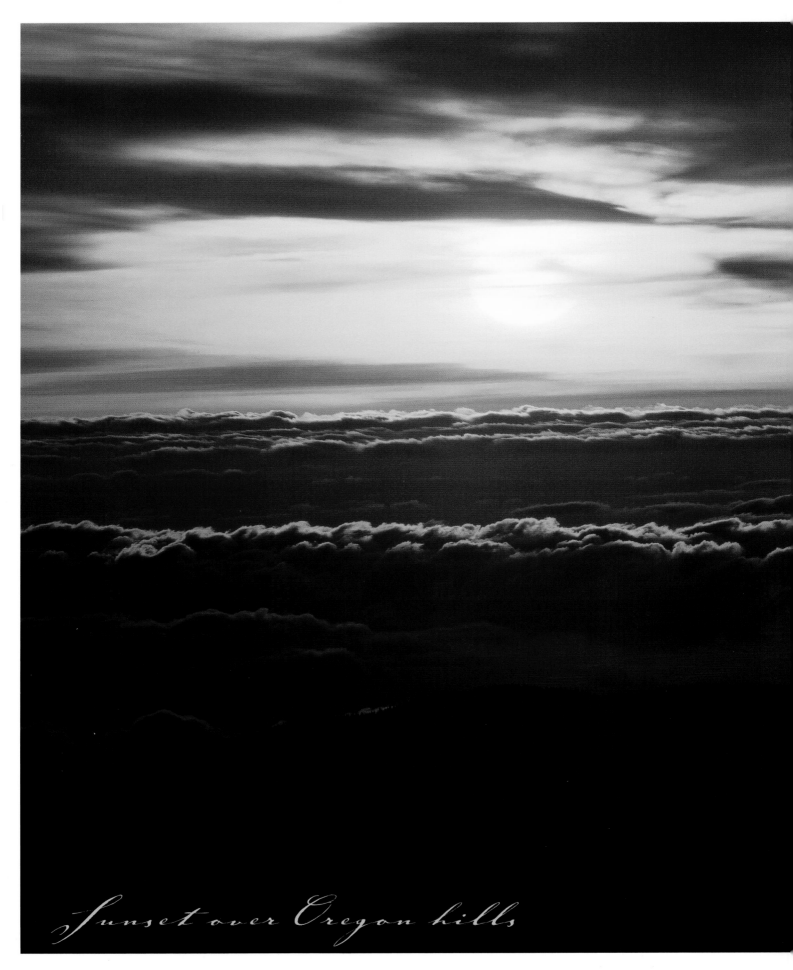

Sunset over Oregon hills

◄ *Sunset over the hills of Western Oregon is a visible reminder of the benign land below. Mild weather, abundant rain, and a lush, fertile landscape combine into a land rich with possibility.*

Acknowledgments

My very special thanks to my wife, Anne, and two children, Matthew and Megan, for their absolute support and unending love. You have truly given me the courage and vision to pursue my love of aerial photography.

Thank you Hillsboro Helicopters, Inc. Your total commitment to excellence and complete customer satisfaction has gone a long, long way in making this book possible. To Warren Petrie, whom I consider one of the finest pilots I have had the pleasure of flying with. Your high level of skill as a pilot, natural intuition, thoughtfulness, and friendship contributed greatly to the success of this book. To Doug Pflugradt, the pilot for all the fixed-wing missions in this book, who gracefully flew us into some wonderful locations. To Max Lyons, vice president and general manager, for running such a tight ship back at the base and being so willing to cooperate and accommodate me during all of my time spent in Oregon. And to contractor and charter Mark Clarke, whose input, aircraft coordination, and advice made my job so much easier.

Thank you to all the folks in Oregon I met and talked to during my many visits: the National Weather Service, the Oregon Department of Fish and Wildlife, Oregon State Parks and Recreation, United States Bureau of Land Management, people from the small local airports, and so many others who unselfishly gave their time, knowledge, and suggestions to this project.

My thanks to Mark Hoole, whose diligent efforts kept systems neat and trim.

Lastly, my deepest heartfelt thanks to Ralph and Linda Bodine, whose very generous support, encouragement, and strong belief in my aerial photographic abilities made this book possible. Thank you both so very much. I could not have done it without you.

—RH

The history and character of Portland and its environs are the stuff of poetry, news, satire, and literature. I am grateful to the many recorders, living and dead, whose words have helped me to form my own chronicle of this place.

—ST